Painting A Likeness

Mr. Caroll Cheverie *Detail 36 x 30 inches Oil on canvas. Collection of Caroll Cheverie.*
This portrait was painted from life, but I later painted a duplicate of it to use as a sample of a portrait of a businessman.

Painting A Likeness

by Douglas Graves

Edited by Diane Casella Hines

North Light Publishers

Published by North Light, an imprint of Writer's Digest Books,
9933 Alliance Road, Cincinnati, Ohio 45242.

Manufactured in U.S.A.
First Printing 1984

Library of Congress Cataloging in Publication Data

Graves, Douglas R.
 Painting a likeness.

 1. Portrait painting—Technique. I. Title.
ND1302.G7 1984 751.45'42 84-1466
ISBN 0-89134-072-6

There is no excellent beauty that hath not some strangeness of the proportion. —Francis Bacon

Acknowledgments

My appreciation to those who've helped me with this book, whose efforts must not go unnoticed:

To—Marsha Melnick, who first asked me to think about a sequel to *Drawing a Likeness.*

To—Diane Casella Hines, my editor, who encouraged me to go ahead with it and then straightened out my jumble of writing.

To—Bill Fletcher and Fritz Henning for believing that the idea would work.

To—Bart Huss for his advice and immense help with the photography and its related problems.

Contents

Introduction

Painting a convincing likeness is essential to a good portrait. It requires two elements: the reproducing of physical characteristics, and the suggesting of character, that elusive inner spirit behind the physical facade—the soul of the sitter. It isn't technical mastery alone that moves the viewer of a Rembrandt portrait; it's the spirit—the essence—of his sitter that Rembrandt has immortalized along with the sitter's features. And this he achieved, I believe, through both superior draftsmanship and keen observation.

The achieving of "essence" in portrait painting is a very personal matter. I encourage you to find your own unique statement of your subject; but it is yours, and I can't tell you what it should be. I think I can help you, however, with the other important aspect—achieving a physical likeness. This book is a working manual for that problem.

Keeping in mind the goals of observation and draftsmanship, the book is divided into three sections. In Section 1, "Studying Individual Features," I've painted a series of heads, and emphasized one of the features to show how, for example, a different eye shape can be a strong factor in capturing a likeness. In the last part of this section there are groups of heads with the same features, but with the relationship of the features changed—by a larger space between the eyes, a different size mouth, and so on. By carefully comparing and observing these heads you can begin to sharpen the powers of observation that are so essential to painting a likeness.

Section 2 presents a series of demonstrations in black and white, each with thirty steps. In these demonstrations I assemble the facial features and parts of the head that were analyzed separately in Section 1. I've purposely eliminated the use of color here so that you can concentrate on achieving correct proportions and establishing tonal values without being distracted by problems of color. I strongly urge you to follow the entire procedure, all thirty steps, for each demon-

stration. I've broken down my painting procedure into these individual (sometimes quite detailed) steps so that you can see how each brush stroke contributes to the overall solution.

In Section 3 I've painted three step-by-step demonstrations in full color. The sitters are varied, to give you several facial types and skin colorations, but you'll notice that all of the demonstration portraits are frontal views. Once you master the full front view, the three-quarter view will be much simpler to paint. The profile pose is rarely seen, so I've chosen not to use it in the demonstrations. However, I'll discuss both the three-quarter and profile poses later, in Section 4.

My previous book, *Drawing a Likeness,* stressed the necessity for acute observation and careful draftsmanship in order to achieve a likeness. The same is true for painting a likeness, with the added problem of color. At first you might think that color would be the most important way to achieve an accurate likeness. However, getting the color of a person's skin, eyes, or hair exactly right will not, by itself, transform a poor likeness into a good one. Color is just one of many fundamentals that must be considered if the likeness is going to be faithful to the sitter.

While a person's race or color of skin is essential to his overall physical appearance, it doesn't, of itself, have any more importance than the color of his eyes; race is just one of many factors that make up the face of a man or woman. For this reason, I don't spend a great deal of time discussing ethnic coloring or racial characteristics.

What is essential is learning to view the very individual shapes and relationships of the features on the face posing in front of you. And that's what this book will emphasize. If you master the art of careful observation and delineation, you'll master the art of painting a likeness.

Section 1A

Studying the Individual Features

Introduction

The heads that follow are arranged according to their importance in painting a likeness, with the most important feature, the eye, appearing first. You might think that a beard, a moustache, or eye and hair color are more important in establishing a person's likeness, but in the series of paintings that follow I'll show you why this isn't so. The following is my list of physical features arranged in order of importance, though not necessarily the order of painting:

> eyes
> mouth
> nose
> eyebrows
> head shape
> eye color
> hair color and hair style
> skin color
> beards and moustaches

In this section you'll find a variety of examples for the three characteristics of each feature listed: shape, size, and placement. There will be a variety of head shapes to study, as well as different eye colors, hair colors, and hair styles. Ethnic skin colors and facial hair will be dealt with only briefly, because I feel they aren't critical to painting a likeness.

When you're learning to discern the slight differences in features among individuals, practice by looking at people you know (when they're not aware that you're doing so). You'll probably feel strange at first about coldly analyzing the faces of your friends and relatives, but as a portrait painter you must become accustomed to looking for those differences in features that make a physical appearance unique in a sitter. Such careful observation won't make you lose your sensitivity to the inner personalities of your friends but will enhance it, and will improve your ability to paint their likenesses.

With many of the heads that follow in this section, you can begin to train your eyes to detect the subtle differences among human faces. Because the eyes are the most complex in structure, they have the most variation in size, shape, and position, so I'll begin with them.

Please note that in the paintings of individual heads, as well as in the black-and-white and color demonstrations, when I refer you to right or left with regard to position on the head, I always mean the *viewer's* right or left.

Eyes

The eyes are the most important features because you notice them first. Usually you form an impression of a person's total appearance based on the eyes. The muscles around the eyes aren't very mobile, which limits the eyes in changing their apparent size. Also, the shape and the placement of the eyes on the head vary only slightly from person to person compared to, say, the mouth. Since eyes come in pairs, the distance between them becomes another proportion to consider. Eye color also strongly affects a person's appearance, as you'll see in the color demonstration paintings in Section 3. The examples here begin by illustrating differences in eye shape.

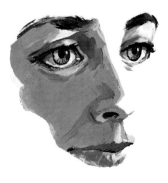

Figure 1: When analyzing the shape of an eye, you have to start by comparing it to a "normal" or average eye, in which the upper eyelid is slightly angular and the lower one is curved; the lids cover the eyeball; the upper lid crosses the upper tip of the pupil, and the lower one loops under the bottom edge of the iris.

Figure 2: These eyes have a more angular look to both their top and bottom lids. Notice the staggered, converse lid shape of the eye itself between these lids.

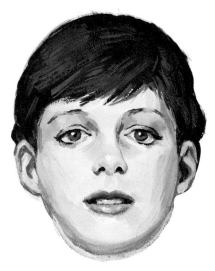

Figure 3: As a rule, if you draw a line between the two corners of the eye, from the tear duct on the inner corner to the outer corner, the line will rise at the outer corner, if ever so slightly. With this pair of eyes, the reverse is true; the outer corners are lower than the inner ones. A noted entertainer, Ms. Liza Minelli, has eyes shaped like this—not usual but very attractive nonetheless.

Figure 4: The lids on these eyes are more curved, especially the lower lids, giving the eyes a round appearance.

12

Figure 5: The eyes of this young man look small because both the eyeballs and the eyelids surrounding them are smaller than average.

Figure 6: The diameter of an eyeball averages about one inch, but this size can vary a fraction or so among individuals. Even such a small amount can make a big difference in appearance, as seen in this female head.

Figure 7: The placement of the eyes varies among individuals, not only with respect to their location between the top of the skull and chin, but also in relation to their distance from other features. With this male head, the eye placement is lower than usual in relation to the eyebrows. It's more like the placement usually found on a woman.

Figure 8: The older woman here has an eye placement that is much closer to the brow than average. Her eye placement is more characteristic of a male head, but it doesn't detract from her attractive appearance.

Mouth

The mouth is just slightly less important to individuality than the eyes. It can sometimes be the most expressive of all the features, and often taxes the powers of the most experienced portrait painter. The often-repeated aphorism attributed to Sargent, "A portrait is a painting of someone with something wrong with the mouth," couldn't be truer. Because the entire area of the mouth is so flexible, it can assume a wide variety of shapes and sizes.

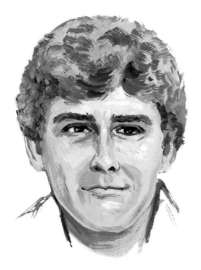

Figure 9: An illustrator considers an ideal spacing between the eyes, across the bridge of the nose, to be the width of one eye. The eyes on this young man are closer together than that ideal distance. For an example of eyes that are wider apart than the ideal, check Figure 17.

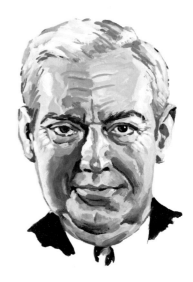

Figure 10: The imaginary line taken clear across this pair of eyes would slant upward on the right. Look for this eye lineup as being a very common variation from the ideal. Careful interpretation of the eye alignment is absolutely necessary when trying to achieve an accurate likeness.

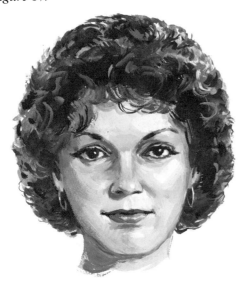

Figure 11: The ideal shape for a mouth seems to be one that's as wide and deep as the one pictured here, which belongs to my editor, Diane Casella Hines. Each corner of the mouth in repose lines up with the inside edge of each iris. The upper lip isn't quite as deep as the lower one.

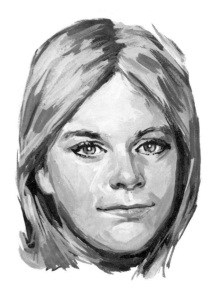

Figure 12: This mouth is wider than average. When smiling, the shape and dimensions of the mouth change a great deal. But in this case the mouth is rather set and not smiling.

14

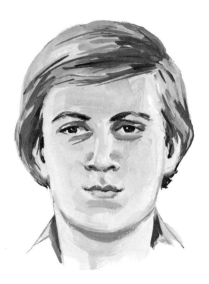

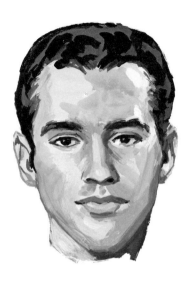

Figure 13: This mouth is narrower than the ideal mouth, especially for a male. Other heads in this section have small mouths, e.g., Figure 5.

Figure 14: The wider, heavier lips evident in this mouth are characteristic of both sexes of African and Asian descent.

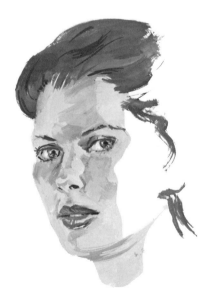

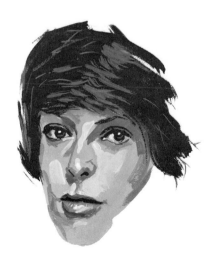

Figure 15: It appears that the upper lip on this mouth is thicker; however, it's the same width as the lower one. We're used to the upper lip on the average mouth being thinner than the lower one, and this is what causes the appearance here of a thicker upper lip.

Figure 16: In this case, the upper lip is thin in relation to the thicker, lower one.

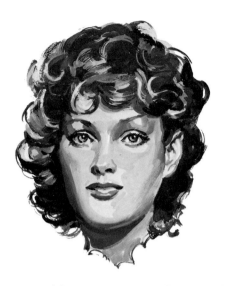

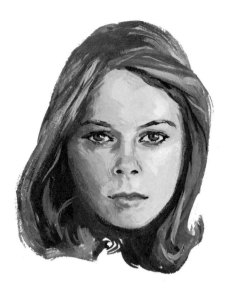

Figure 17: The usual distance between the nose and mouth is equal to the depth of both lips. (Check that measure on the other heads in this section.) But with this head, the space between nose and mouth is narrower than usual, so that the chin seems larger. Such a proportion, though unusual, isn't unattractive.

Figure 18: On this head, the distance between nose and mouth is greater than the depth of both lips. Such a proportion drops the mouth down lower in the muzzle area. The dividing line between the lips is actually halfway between chin and nose, but it appears lower because of the unusually large space between nose and mouth.

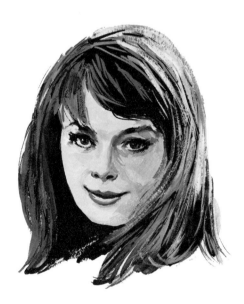

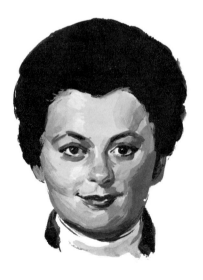

Figure 19: The dividing line of the lips ordinarily goes straight across the face, parallel with the line of the eyes and nose. Even a smile does little to change that straight line. This mouth is an exception, with the corners sweeping up, but not to an abnormal degree.

Figure 20: These lips tilt up toward the right, imparting a very distinctive look to the mouth. A tilt can be found in many faces, but usually is not quite as exaggerated as it appears here.

Nose

What's an ideal nose? What type is most appealing? Check all the noses in this section, and you'll find that the ones you like are usually those that are slender. Men's noses often show a slight bump where the bone ends, and a suggestion of that bump often appears on women's noses, too. The tip of a nose looks most natural when it has a slightly angular construction.

Figure 21: The nose pictured here is ideal in terms of its size and shape.

Figure 22: This nose is a little short for a mature man. The length of the nose is an indicator of age. You must be especially observant of nose length when painting a likeness; it can greatly alter any appearance.

Figure 23: The shape of the nose across the front is usually rounded, but on this one the shape is more flat, so that the nose seems wider. Also, the plane underneath the nose doesn't angle up at either end, which further contributes to the nose's wide appearance.

Figure 24: Compare this nose to the others, especially to Figure 22, and you'll see how the longer length of this nose conveys the maturity of this man. Sometimes, the end of the nose bone continues to grow a little throughout a lifetime, making the nose on an older person larger or longer than when younger.

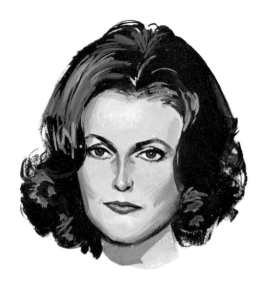

Figure 25: This nose is unusually thin, but it serves to give this attractive woman her air of distinction.

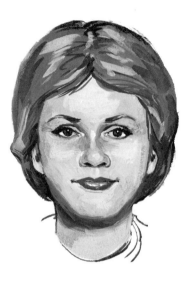

Figure 26: The end of the nose on this girl has lost its angularity; making it bulbous. If this bulbous shape seems unflattering, you might try to light the sitter in such a way as to minimize the shape, or at least you might keep the rendering of it very soft.

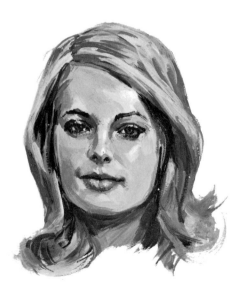

Figure 27: Except for a little wiggle up and down, the nose has no mobility. So any variation in placement from the norm isn't a result of movement. Here one nostril is tilted up on one side; this isn't a matter of movement, but rather of construction.

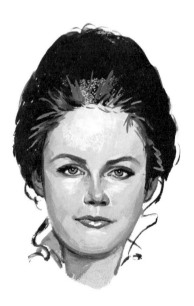

Figure 28: Here the nose bone is obviously off to one side, a variation that can be difficult to ascertain in any view but straight on. You must analyze a sitter's face carefully to notice such differences.

Eyebrows

Eyebrows of men differ from those of women in all three of their characteristics—size, shape, and placement. Women usually have thinner, more arched brows that loop up over the eye socket bone. A man's brows are usually heavier, a little flatter than a woman's, but they also loop and follow the ridge of the eye socket. For both sexes, eyebrows start heavier at the center and taper to a softer inner end.

As the eyebrows rise toward the sides of the head, they are thinner and lighter, and as they descend to their outer ends, they consist of spikes of lighter hairs. Compare all the eyebrows in this section. Eyebrows become fairly important in achieving a likeness because they're so closely related to the construction of the eyes.

Figure 29: These eyebrows have an average shape. Their length starts almost directly above the eyes' inner corners (tear ducts) and extends past the eyes' outer corners flowing down the edge of the eye socket ridge.

Figure 30: These eyebrows have a definite arch. Their construction is apparent here.

Figure 31: These are very masculine brows. Their dark, heavy texture gives this man a virile look. If you cover the lower half of his face, the man's brows still take precedence over his moustache.

Figure 32: At the opposite extreme are the light, wispy brows of this girl; there is hardly anything to them, but they're an important part of her appearance.

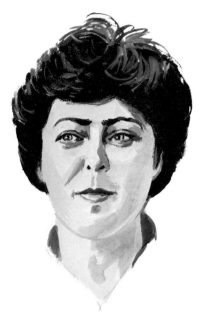

Figure 33: These eyebrows are very close together, almost too close for the average placement.

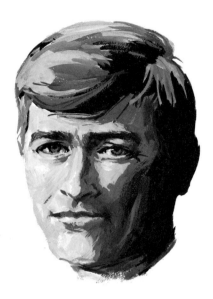

Figure 34: A departure from the conventional eyebrow shape makes the placement different, too. These eyebrows form their own straight line.

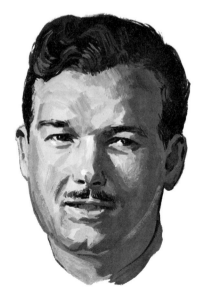

Figure 35: Here are some very small and widely spaced eyebrows. They don't coordinate with the construction of the eyes beneath them.

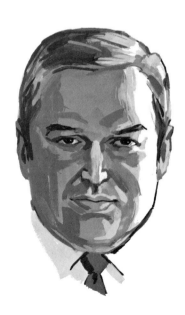

Figure 36: If the eyebrows aren't symmetrical, it gives a very distinctive look to the face.

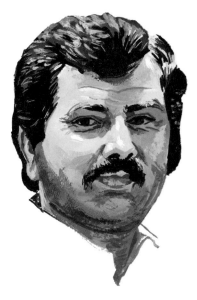

Figure 37: You can look through this book and find many seemingly different hairlines. But actually there are just two basic ones: the "widow's peak" and a more rounded hairline. Men with a widow's peak such as this often lose the hair on either side of it.

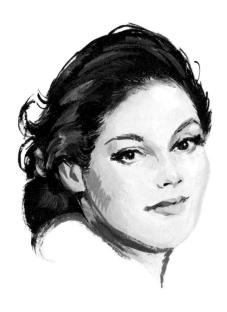

Figure 38: This woman has an even, rounded hairline. Although all hairlines are basically variations of this or the widow's peak, the way a woman styles her hair can often disguise her hairline.

Figure 39: This man's appearance is distinctive because his eyebrows are slightly dissimilar; the distance between the eyes and eyebrows is somewhat narrower than usual; his nose is wider and flatter underneath; and his lips are heavier. It's obvious that skin color plays just a minor part in this man's appearance.

Figure 40: Beneath all this hair (beard, moustache, and sideburns) is a likeness that will still be determined by the eyes, eyebrows, nose, and general shape of the head. Even if this man shaved off all his facial hair, you'd know who he was.

Head Shapes

This category trails the list of important features. Nevertheless, it can't be ignored in your appraisal of a sitter. It may seem paradoxical to start your drawing with a lesser item like the shape of the head, but it's a matter of good drafting technique, even if the head shape itself doesn't really assist in capturing the likeness.

Figure 41: This oval-shaped head constitutes the average skull shape. On someone who has a great deal of hair, it's hard to see where the oval is completed. Skull shape runs a close second in importance to the facial features in defining a likeness. When painting, the skull's facial construction is usually delineated by variations in the skin tones.

Figure 42: This rounded skull shape is less ordinary than the oval one. It really wouldn't appear quite as round if the head were completely shaved, since the hairstyle enhances the round appearance, or if the head were turned somewhat at an angle.

Figure 43: Another unusual shape for the head is square. You probably have seen more faces with this shape than with the rounded one of Figure 42. There are many variations of this shape, such as a more pointed chin, or sides of the head that slant one way or the other.

Figure 44: This head is quite narrow. Sometimes this shape comes with a longer chin or a higher skull. The hairstyle here exaggerates the shape.

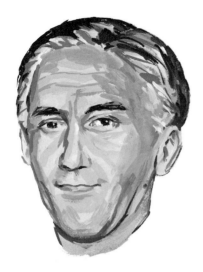

Figure 45: The triangular-shaped head comes from a larger, rounded skull, with a face that tapers down to the chin. The geometric shapes mentioned are, of course, all imaginary. You must be able to superimpose these geometric shapes onto the head of your sitter in order to determine the correct head shape.

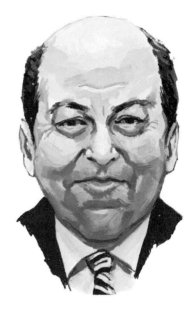

Figure 46: This head is a variation of the standard oval shape, but the chin pushes down out of the oval into a longer point.

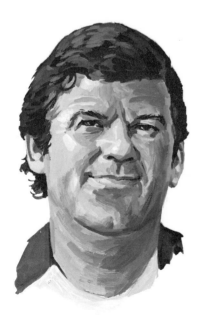

Figure 47: The neck pictured here and the ears seen in Figure 48 are probably the least important features in terms of capturing a likeness. You are more likely to find a broad, brawny neck, such as this one, on a man.

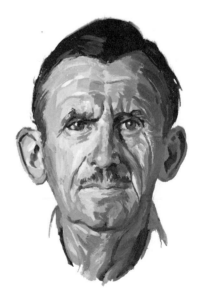

Figure 48: There are other features that are more distinctive about this face than the ears, such as the closely spaced eyes and lack of space between the eyebrows and eyes. Although the ears seen here are larger than average, they are not the principal definers of this man's likeness, but they contribute to it.

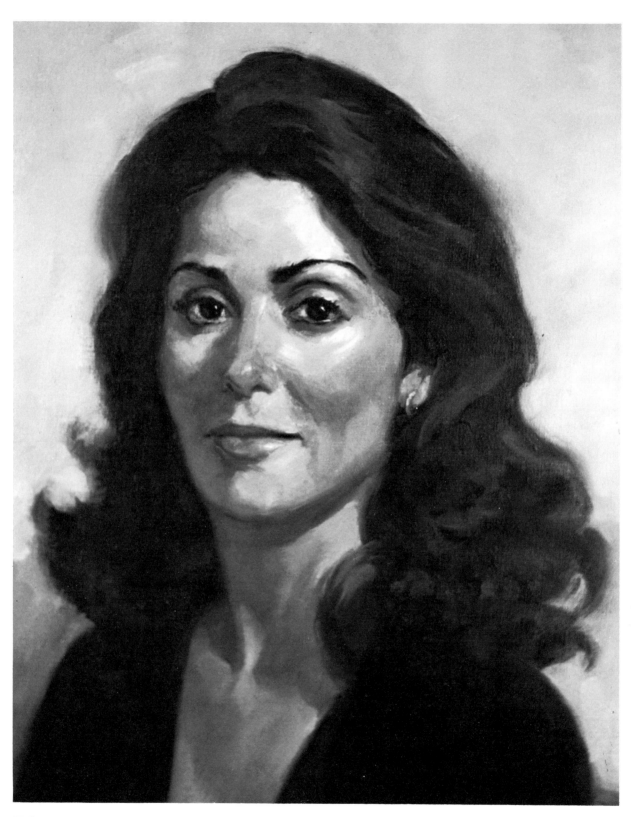

Kathyrn *Detail of a ¾ length view. 36 x 30
inches Oil on canvas. Collection of artist.*
Sometimes I'll paint several poses of a sitter
because I can't decide the one I like best. In this
case, the client didn't select the pose you see here;
she preferred another.

24

Section 1B

Placement of Features—the Keys to a Likeness

Introduction

In the preceding part of this section, you've seen how features vary among people. But now let's take one person and move one feature at a time, just slightly, to see how his likeness changes. In this section, for demonstration purposes, I've done some very symmetrical faces, but you are aware that most faces aren't so perfect. We inherently (and quite automatically) compare a person's features with an ideal we hold in our mind's eye; for example, the ideal spacing between eyes is one eye apart. But you will learn to observe exactly what's on the face of the sitter and use the imaginary "ideal" placement only as a point of departure.

On these very symmetrical faces, I've altered one feature or set of features just a little. Each time I do that, an entirely different personality and likeness emerges. Perhaps one eye is a little higher then the other or the mouth is just a bit slanted. As you delineate these little deviations from the "perfect" set of features your portrait becomes lifelike and faithful to the sitter.

Head Shapes

There are five general head shapes: oval, triangular, narrow, square, and round. In the previous sections you learned to look for these shapes on different people. Here I'll demonstrate how a change of head shape alters the appearance of the same person.

Figure 1: An oval head seems to be the most common shape. (It's difficult to paint a head without some other identifying characteristics, so, along with head shape there will be other features.)

Figure 3: This head is narrow. I've exaggerated it here to show the shape more clearly.

Figure 2: This is a shape that becomes more triangular with the top of the skull widening out from a somewhat pointed chin.

Figure 4: The square shape of this head is most noticeable around the jaw.

Figure 5: This head type only occurs once in a while. Mostly heads are more oval.

Noses

Here are six different nose shapes that can serve as a basic reference for almost all sitters.

Figure 6: This nose is of average size and shape.

Figure 7: A shorter nose often seems to make a person look younger.

Figure 8: The narrow nose bone changes the appearance around the eyes.

Figure 9: A longer nose imparts still another look.

*Figure 10: A common im-
balance in the symmetry
of features is one nostril
that's a bit higher than the
other.*

*Figure 11: A wide nostril
is an exaggeration of the
average.*

Mouths

These six different mouth shapes represent almost all the types you're likely to encounter.

Figure 12: The ideal mouth is often placed above center in the muzzle area. The corners of such a mouth fall directly under the inner boundaries of the irises.

Figure 13: When the ideal mouth tilts down on one side, the face acquires a distinct personality.

Figure 14: This mouth is narrower than average.

Figure 15: This mouth has a normal width but its position is dropped down on the face somewhat.

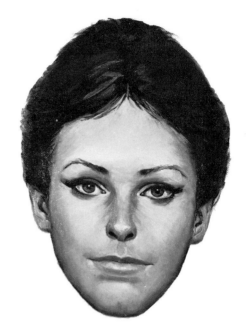

Figure 16: A higher than average placement charac-terizes this mouth.

Figure 17: Here's a wider and all-around larger mouth.

Eyes

The five heads seen here have eyes in different positions in relation to the rest of the features. These eye placements are very subtle, more so than the placements of other features. They illustrate that very minor changes make great differences in capturing a likeness.

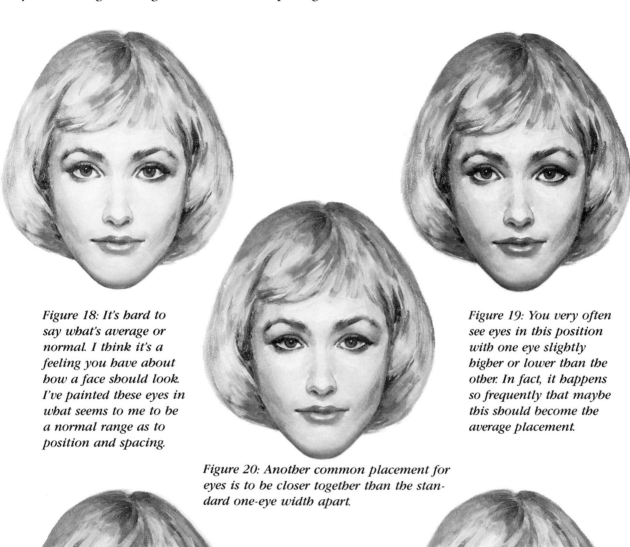

Figure 18: It's hard to say what's average or normal. I think it's a feeling you have about how a face should look. I've painted these eyes in what seems to me to be a normal range as to position and spacing.

Figure 20: Another common placement for eyes is to be closer together than the standard one-eye width apart.

Figure 19: You very often see eyes in this position with one eye slightly higher or lower than the other. In fact, it happens so frequently that maybe this should become the average placement.

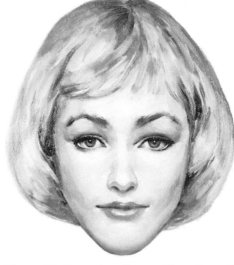

Figure 21: While on the same eye-level, these eyes are placed farther apart than the standard one-eye width.

Figure 22: Lowering the eye line along the centerline of the head imparts an entirely different look to the face.

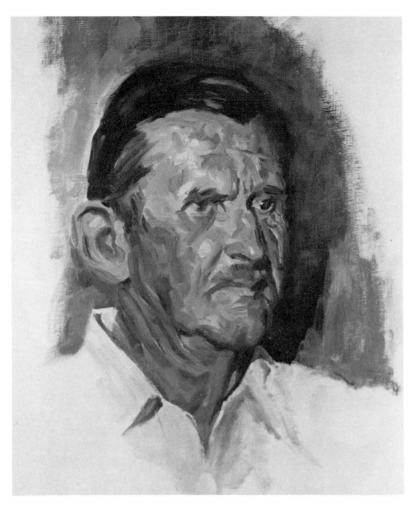

Chet Jastromb *20 x 16 inches Oil on canvas.*
Collection of artist.
This is a preliminary study made for a formal
portrait. These studies are painted quickly and
have a spontaneity that is often lacking in the
finished portrait.

Closing

In the heads on the preceding pages I've tried to illustrate the slight
differences in shape and placement of specific features that create
what we call a person's unique appearance, or likeness.

Few people have perfectly designed and balanced features, and
those who do are said to have faces that lack "character." It's all of the
little imperfections—the features that differ from the ideal—that
give each of us our unique appearance. In portrait painting, symmetry only plays a role in the underlying perception of the head. It's the
asymmetrical placement, the slight deviation of features from the
norm, that helps to create a likeness. Look for these deviations of features in all the heads throughout this book. Such study will improve
your powers of observation when you analyze your next sitter.

Section 2

Putting It Together—Black-and-White Demonstrations

Introduction

I n this series of demonstrations, I reassemble the individual features that were analyzed in Section 1 to create likenesses in black and white. I take all the pieces and, in many steps, slowly put them together to construct a portrait. The same procedure is followed in all the demonstrations, with minor exceptions. For example, a different kind of lighting on the model may necessitate altering the procedure somewhat.

The photographs used in this section serve as substitutes for sitters. But it's often necessary to paint from photos, so doing these demonstrations in this manner will be good practice for all of us.

When learning to paint portraits it's important to follow a set method. Later on you can deviate from such a method without becoming confused. If you've ever watched a demonstration given by an experienced painter, you may have wondered how his seemingly unorthodox approach could work. But somewhere in his mind he has a procedure much like anyone else's (perhaps even like mine); he has either compressed the steps or changed them for the sake of convenience. You'll probably do the same yourself someday.

Meanwhile, I urge you to follow each step in these demonstrations. Don't miss any, and see if they make it easier for you to get that likeness. Also, by making each brush stroke an event, you'll avoid carelessly throwing paint around. In fact, while I was painting the steps for these demonstrations my own performance improved, because I was being more thoughtful about each step.

Of course, it's always fun to skip around through the book to find the parts that interest you most. But I ask you to concentrate on the series of steps first. Copy these demonstrations stroke for stroke, not for use as finished paintings but just as practice exercises. Then get your own sitter or use a photo, and begin to paint on your own, using the same procedure, in black and white. You'll be surprised at how much your work improves.

Materials

For these black-and-white demonstrations the materials are just three colors: titanium white, ivory black, and burnt sienna. Why burnt sienna for black-and-white paintings? It's my personal preference, but more importantly, burnt sienna adds warmth to the gray tones produced from black and white. Without it, the grays have a very bluish cast.

To produce my grays, a good proportion is something like three-

quarters of burnt sienna to one of black. Squeeze out the proportions in lengths beside each other. For instance, if you think you need a little more than an inch of black color, squeeze about three-quarters of that amount of burnt sienna beside the black. Then mix the oils thoroughly with a palette knife.

The black-and-white painting in the three demonstrations of this section will require between three and four inches of black per painting. Sometimes we'll need a little more. The black and burnt sienna on the palette seem to be quite brown, but the mixture appears black enough on the canvas. When you add white to this mixture, it produces beautiful warm grays.

The brushes I use are mainly filbert hog bristle oil brushes, although I also use a few sable oil brushes. The sizes and numbers of my brushes are:

> 2 #8 hog bristle filberts
> 2 #6 hog bristle filberts
> 2 #4 hog bristle filberts
> 2 #4 R. Simmons 68L bright
> sables
> 1 #3 Grumbacher 626-R round
> sable
> 1 #6 R. Simmons 61-R round
> sable
> 1 #2 R. Simmons round bristle
> 1 #10 R. Simmons Signet 40-R
> round bristle

The type of canvas I recommend depends on the goal of the painting. If it's for practice or experiment, cotton canvas is good. However, a commission calls for a quality linen canvas.

I don't use any medium with my oils, even though I've experimented with all kinds. I'm not really opposed to the use of a medium on any scientific grounds. I do like a brand of oil paint that is "buttery" and blends easily. Permalba and Talens brands seem to fill that need.

I never buy "student grade" paints. They may seem like a bargain but they're not, because they're adulterated. In the manufacturing process, student grade paints are extended by means of a chemical filler that increases the volume of paint produced, making such paints cheaper. But this extending process reduces their quality— their richness and coverage. So, in the long run, you have to use more of such paints to achieve the same effect possible with much smaller amounts of a better grade.

Demonstration 1

Oval-shaped head

Now that we've analyzed the individual facial features, let's put some of them together and actually paint a portrait. Imagine yourself looking over my shoulder in the demonstrations that follow while I paint each step. As I've said, we'll have to work from a photograph of the sitter rather than a live model, but this will be good practice, since it's often necessary to work from photographs when a sitter isn't available.

These demonstrations are purposely limited to black and white to relieve you of the added problems of color for a while. Later, when you feel more confident about the drawing of tonal values, color can be given more of your attention.

In these demonstrations, when painting the basic values, I use a fully loaded brush and heavy strokes. I think about each brush stroke as another piece in an intricate puzzle, and try to anticipate where the edge of a new brushstroke will go before I lay it down.

When trying to determine the correct position for all the parts that constitute a portrait, I like to use a combination of "eyeballing" (relying on just my eye to determine dimensions and distances), and actual measuring. Don't be bashful about using a ruler or wooden caliper on a live model. On your photo or painting, you can more accurately judge distances with dividers.

No matter what style or technique you use, your main concern here is to make the portrait look like the sitter. You can be just as freewheeling with paint or as tight in your rendering as you like, as long as your portrait captures both the physical and spiritual essentials of your sitter. Through the steps of these demonstrations, I hope to convey both my technique and thought processes right through to the completed portrait.

Oval-shaped head

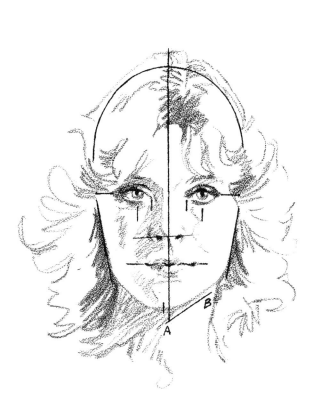

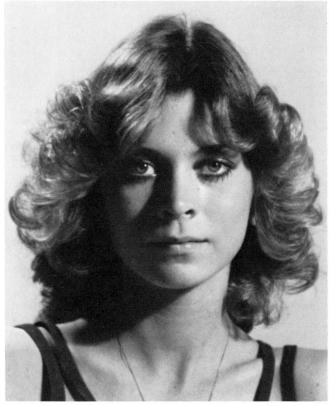

Figure 1: *This head shape is based on an oval, but it's smaller at the lower end, which is characteristic of women. Another female characteristic is an eye line that is somewhat below the academic "halfway" mark. This head's oval shape becomes angular at the lower sides and along the chin.*

The eye line and mouth line are both perpendicular to the vertical line, but there the symmetry ends, because the whole left eye is closer to that line than the right one. The nostrils tilt up to the right. The most distinguishing characteristic of this head is the angle of the chin at A-B which cuts in quite steeply, pulling the point of the chin over to the left.

Figure 2: *It's fortunate to have Terri as my first sitter. She's a beauty-pageant winner with awards for her beauty and talent. In the straight-on view in this photo you see an almost symmetrical set of features. That's an important criterion for being a beauty-pageant winner. But such winners must also possess an additional component called* character *that is also apparent in their faces. If you examine this photo of Terri very closely, you'll see tiny variations—flaws if you will—of her features that at first glance weren't noticeable.*

This portrait will be fairly easy to paint because of the lighting. It's an outdoor, natural light that casts strong shadows. Such shadows create very definite contrasting tones that help to define facial structure and features. That makes the job easier because you don't have to render all the subtle, high-keyed tones of the young, smooth, female face.

Step 1: Terri's head is an oval shape, so I'll outline it first in black paint. In a straight-on view like this, it's a good idea to divide the head with a vertical centerline. Usually, with a woman it's hard to tell where the top of the skull is, because her hairstyle usually obscures it. But in this case, you can almost see it. You'll notice that the eyeline doesn't divide the head (oval) in half equally, because this sitter has a shallow chin (more common in women than men).

Notice also that the sides of the oval are cut off at the cheeks. Next, the line for the mouth is drawn across the vertical centerline, below the eye line. In Terri's case, both the eye line and the mouth line are at precise right angles to the vertical centerline.

Step 2: Here I rough in the outline of the hair with vague, dry brush strokes. The hair boundaries at the neck are formed at the same time. It's fairly easy to estimate the size of the hair masses. In the forehead region we get a good clue to the position of the eyebrows, due to the hair that falls directly down above them. With large dots, I locate the irises, measuring them carefully in relation to the vertical centerline. In this case, the eye on the left is closer to that line than the one on the right.

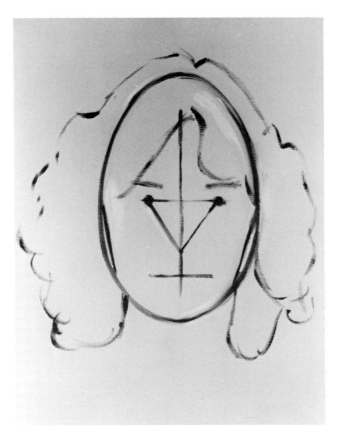 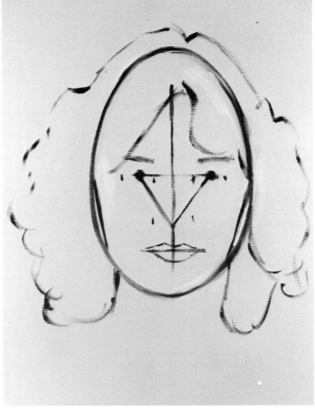

Step 3: In order to locate the bottom of the nose, I've devised a means of triangulating with the irises. I've always had difficulty estimating the length of the nose correctly because of the empty space from the eyes down to the mouth, which has no landmarks. It's hard to relate the nose length to anything else. But it becomes relatively easy when I draw in a basic shape like the triangle shown here. I use the two irises as the two top corners of the triangle, with the third corner, or point, of the triangle falling at a spot under the nose.

Step 4: Now I outline the mouth area with a more or less simplified shape. Marks for the boundaries of the eyes' outer corners are placed, as well as the outside dimensions of the nose wings above the nostrils.

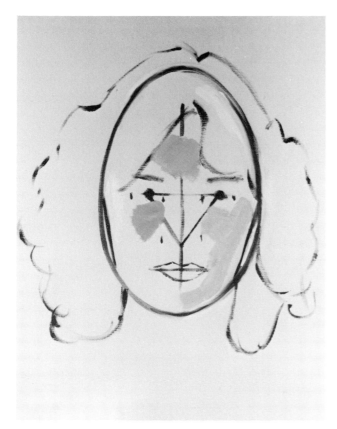 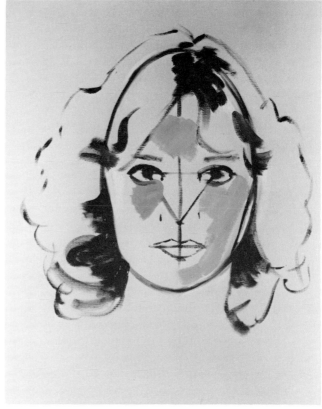

Step 5: At this point, I begin blocking in with two flesh tones. The lightest one is painted along the right side down to the chin with some on the forehead as well. The cheek on the left is lighted with a spot of tone that's not as bright as that on the right. For that left cheek area, I use the second, darker flesh tone.

Step 6: At this time in any portrait, the darkest portions should be at least suggested. Using black pigment, I paint in the hair in several places. With some of that black and a small, flat sable brush, I stroke in the eyelids. This can be done in one sweep, leading with the sharp side of the brush and starting at either corner. As the brush sweeps across, I twist it so that the stroke widens out. (You may want to practice making such strokes on an old piece of canvas.) The lower lids are painted with a black line from the outer corners and then a lighter tone is placed over that line.

Step 7: In this step, value is mixed for the shadows that's about a #6 on the scale. With it the massive shadow on the left is painted, using plenty of paint to make one simplified statement. This same tone is used on the right side of the chin, but it becomes lighter as it sweeps around the side of the face. There are several different areas in the hair where this shadow tone can also be used, such as the bottom near the neck, and the crown.

Step 8: For the transitional areas between the shadows and the light, the halftones, I use a value that's halfway between the basic flesh tone and the shadow tone. These halftones occur on the light side of the face from its edge to the nose and under the right eye; they also merge with the large shadow on the left and mingle with the lighter values that go up through the eyebrows. The reflected light on the left-side jawline can be painted with this same halftone value, using a #6 bristle Filbert loaded with paint. Right at the neck-line, I lightly smear the halftone with my finger, and place a spot of halftone under the mouth.

Step 9: Now that I've established portions of the darkest tone, I can paint in the lightest ones. Places like the light on the forehead, the one spilling down the cheek on the right, the one next to the nose on the right and under the mouth all need this very light tone. I call these areas "highlights" and will refer to them this way throughout the book.

Step 10: The development of features begins here with the nose. The side of it in shadow has already been established. I add to that side a long, narrow tone that's even darker, a #7 value. It's called a "core" shadow; the main light source doesn't reach it and reflected light doesn't affect it either. The front and side planes of the nose are defined by another long strip that falls in the light next to this core shadow. A halftone painted with hook-like strokes delineates the bottom of the nose around the nostrils. I then paint in the comma-like shapes that compose the nostril openings, using pure black. Next, the pointed tone of the nose wing on the right is painted, and the other wing is cut around with a tone darker than the shadow. Lastly, I flick in some highlights on the nose's bridge and tip.

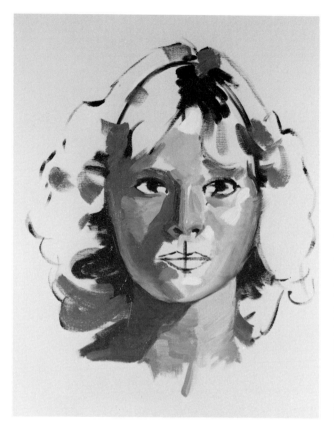 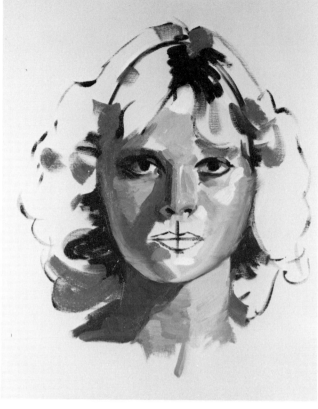

Step 11: Here I fill in the neck with three basic values: highlight, halftone, and shadow. The shapes are roughly indicated to show the light and shadow pattern.

Step 12: An indication of the eyeball with tones of white is roughed in. These are darkest at the outside of the eye on the left and get slightly lighter, with a halftone on the inner side of the other eye. Pure white is used for both eyes where the light hits the eyeballs. I paint the upper lids with black. The left one, which has more of an arch, has an additional halftone between the lid and the eye. The dark lines of the lids come down past the tear ducts toward the nose. Dark lines come from the outer lashes and end in points forming the lower lash lines.

On the right side of each eyelid, a short brush stroke of lighter paint defines its curve into the light. Under the right eye, a dark halftone (between values #6 and #7) starts on the inside as a wide stroke and narrows as it sweeps up under the outer corner. Small shadows placed on the eyeballs begin to show their depth.

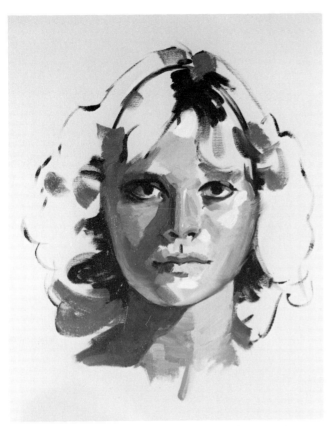

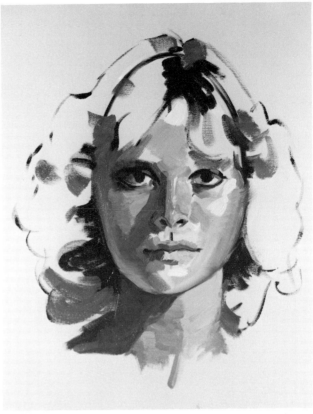

Step 13: Here I begin the mouth simply, starting with a mass of tone around its perimeter to define its shape. However, enough of the mouth's outline is left showing through so that I can keep its proportions correct. The upper lip is a bow shape that picks up reflected light from below. Just the opposite effect occurs on the lower lip, which is dark on the left. The shadow under the lower lip is strengthened and then the underside of the mouth is smeared with my finger. A black line separates the lips and indicates its corners.

Step 14: Returning to the nose, I give more shape to its lower part. A somewhat darker line is painted around the top of both nose wings. The underside of the right nose wing is lightened with a basic flesh tone. The nose's core shadow is extended along to its underside. I had to correct the spear-shaped highlight on the right, because its angle was wrong. In the center of the nose I add a light bit of paint to start creating roundness there.

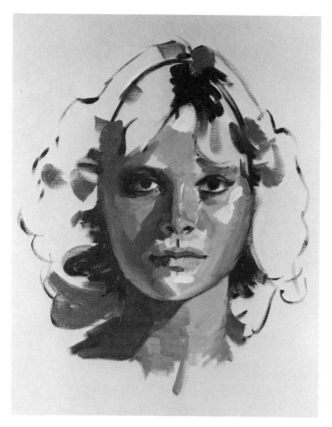 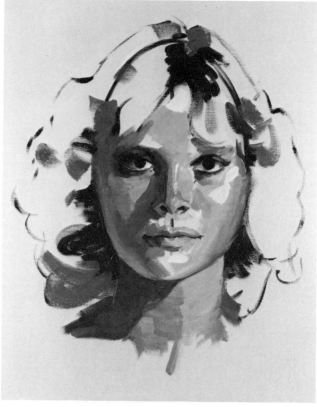

Step 15: To further define the eyes, I give more roundness to the irises. Using smaller, pointed sable brushes, I model the whites of the eyeballs and other eye tones. As an example, on the right side of the right eye the cast shadow on the white part is corrected, blacks are worked into the surrounding tones, and the eyelashes are begun. Under the other eye, the tones are modeled to flow into the cheek.

Step 16: Now the mouth is further refined with additional tones. The upper lip becomes about four tones instead of the original two; from right to left, the tones are lighter, a little darker, darker still, ending up with reflected light. The lower lip is broken up into several smaller values to show the dip at its center and the modeled left side. Above the top lip, I start to define the edge that turns into the light and curves up toward the septum of the nose.

I'm careful to avoid any hard edges on the mouth, so that its appearance remains soft. For example, notice where the edge of the separation line between the lips is somewhat broken up. I like to use my little finger to blend in such places.

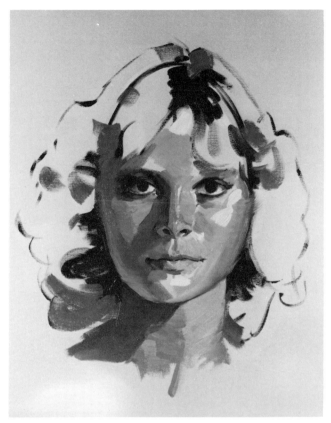

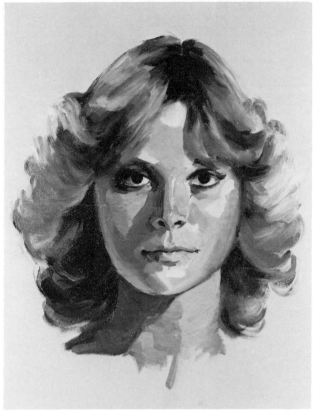

Step 17: Now the features are beginning to resemble Terri, but the unpainted canvas between the nose and mouth starts to mar the likeness. So, in a simple fashion, I begin to paint that area with a large, light flesh tone that goes over to the septum (the dividing wall of the nostrils). The shadow that it casts is denoted with a couple of halftones. As that crease turns back into the light, it's very bright, almost white. On the other side of the septum on the left, a plane slants back in a series of darker halftones. It merges into the lip on the bottom and meets the cast shadow of the nose on top.

Step 18: To keep all areas of the painting developing at about the same rate, I now start to work on the hair. Great brushfuls of tone from black to almost white are blocked in all over. The range of tones in blonde hair is amazing. It's tempting to try to finish the hair at this stage. Many spontaneous passages look just right, so I leave them as is. But I avoid trying to finish the hair entirely and instead try to capture the largest, main forms with my largest brushes.

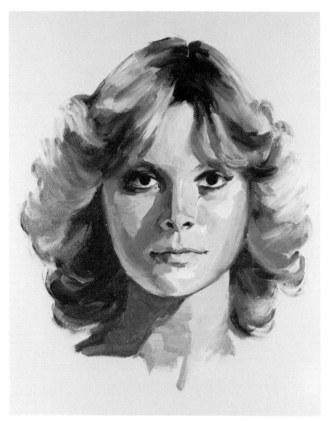 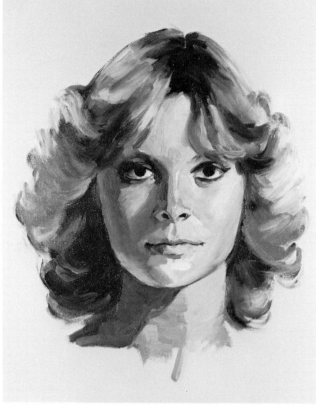

Step 19: It's a logical progression to work now on the facial tones, starting at the forehead. I work the large highlight into the tones there, making certain that it darkens gradually. From the bridge of the nose and the highlight over the eyebrow, I follow the same procedure in an upward direction. If the paint is still wet, I can do this with light strokes, cleaning the brush often. If the paint has dried, fresh paint should be used.

The hair surrounding the flesh tones can be integrated into them. Notice how the streak of hair on the left picks up light and loses its edge into the forehead before the cast shadow defines it down to the eyebrow. On the right, the hair starts out dark and edgy; as it cascades down, its edge is ultra-soft until it nearly reaches the eyebrow, where the edge becomes sharp again. I look for all of these various edges and even exaggerate them. This gives the portrait a three-dimensional quality without sacrificing the likeness.

Step 20: In the cheek area, the same procedure is followed. All the large tones are pulled together, either by blending with a dry brush (I only use my finger for blending small areas) or laying down fresh paint, working it back and forth. The cast shadow of the nose is given variation to break up its knife-edge. The shadow on that side has also become too light, so I add a darker value to it.

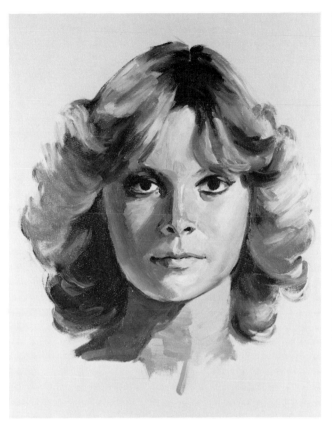

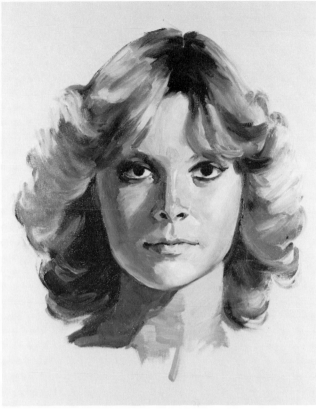

Step 21: Here I work on one small part of the section above the mouth and a little to the side on the right. There's a small plane that turns in from the light streak above it down to the mouth. The blocked-in values directly under the mouth are brought together. The reflected light on the left side of the jaw now seems too light; I lay down an intermediate tone between its darkest part and its edge, and then smear the paint with my finger.

Step 22: This is a continuation of the last step, where I blended the tones on the chin. Different shades are painted and brushed into each other. Even though the part around the point of the chin is a small area, I still use brushes for blending, because there are too many tonal gradations to smooth with my finger.

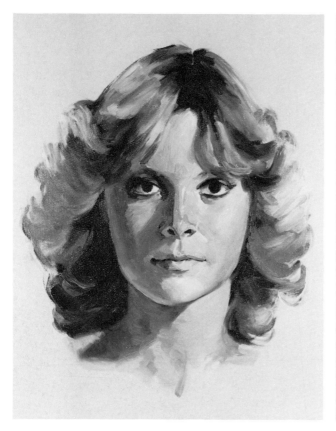 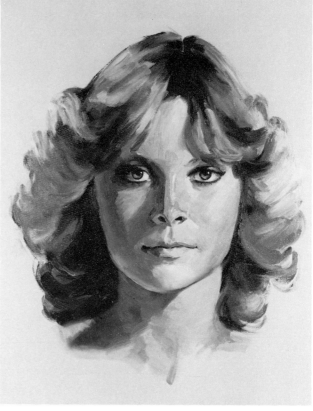

Step 23: The neck and the hair next to it are painted to refine their shape. The light part of the neck turns gradually and breaks the vertical edge down its center. The wisps of hair on the neck's right cross its edge and fade off down to a cast shadow below. Over the large cast shadow on the neck's left, a tone lighter than the underpainting is laid down, except where there's an indentation just left of the center. This small dark spot defines the sternocleido-mastoid muscle that angles down. As it comes into the light, a light paint stroke on the muscle itself shows its continuing course. I soften the cast shadow's edge and all others on the neck.

Step 24: Now I finish the eyes. I've already checked all the large masses of the face for correct proportions and values; so doing the finish is now the frosting on the cake. I use a small bright sable #4 for the touch-up on the whites of the eyes. Two striking refinements of the eyes are to bring the deep shad-

ow on the left eyeball in closer to the iris, and to cut off more of the inner corner of the right eyeball in the tear duct area. These two changes help the eyes track correctly. This is when disaster could fall. If the eyes don't seem to track (that is, look in the right direction), you may start to shift the position of the irises, when all you need to do is make the tiny changes that I've made here.

The left eye seems a little droopy, so I bring the white up higher, which brightens the eye. Don't lose the four different tones that compose the whites of the eyes as you're refining them. The color of the irises is a #4 on the value scale. It is painted in with one stroke. Using a small bright sable, I begin at the left and twirl the brush as it rounds the pupil. The tone should fade off as it comes up toward the highlight. If the black paint underneath is wet, the tone will do that automatically. I add the highlight with a glob of white on a pointed sable and just barely touch the canvas with it. Finally, the lids and lashes are softened.

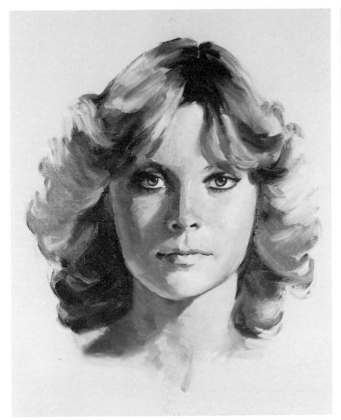 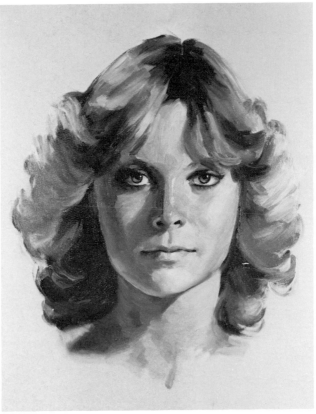

Step 25: Now the nose is refined. The wing on the left appears too high, so I make tiny transitional tones down into the point to shape it. I also modify the shadow next to the reflected light underneath that nose wing. The core shadow on the nose is widened and loses itself into the black of the nostril opening. A new value, directly under the center of the septum, softens that small area. The front of the tip and around the top are softened into adjacent tones.

Step 26: I work down from the nose and soften the indentation between the mouth and nose. The bow of the upper lip is made smoother. I don't want to lose the softness of the edge, yet it mustn't be so undefined as to lose the drawing. The cleft on the top of the lower lip isn't the right shape; it should be narrower. So, I correct it. There's quite a hard edge along the lower edge of the lower lip. Small strokes of lighter tones round it more. Now I soften the corners of the mouth where the separation line ends, by partially covering that black line with some lighter grays.

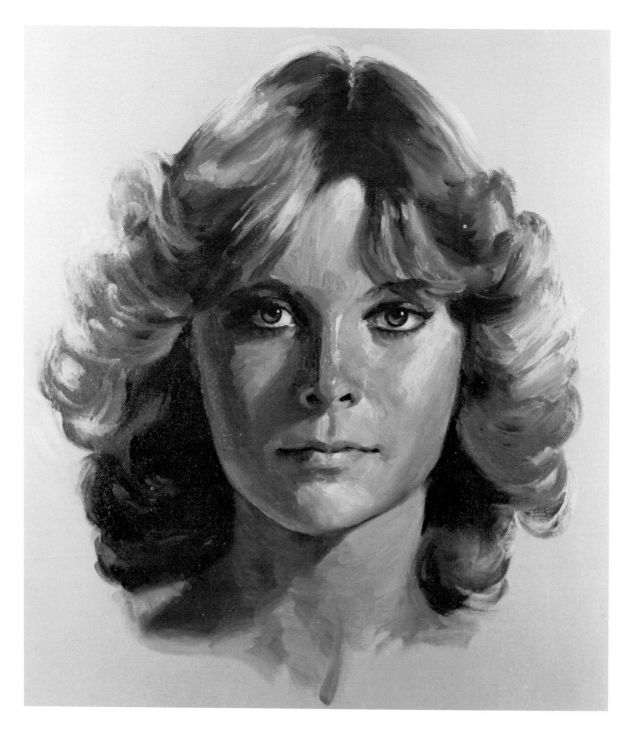

Step 27: The hair is now finished with some additions and corrections, such as softening edges into the background. In a vignette painting like this, all that's necessary is to mix a tone to match the canvas. The hair pigment can be merged with it.

On the left center some additional tones are added, both highlights and light filtering through from the background. Many of the transitions within the hair are softened as well, such as that on the upper right, clear down to the neck.

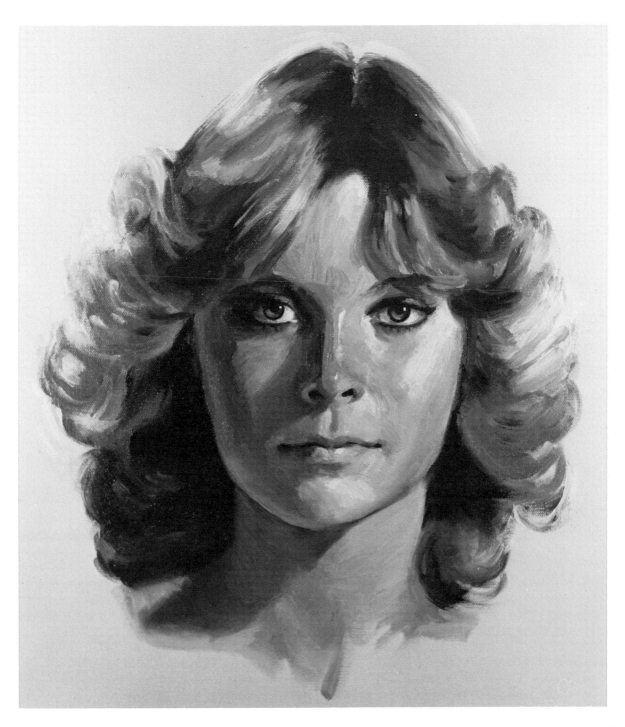

Step 28: At this stage, the neck tones are softened a great deal. The edge of the cast shadow is straightened a little to give the neck a smoother, youthful look. All the changes in values are sub- *tle. (Regardless of your sitter, you can use artistic license and make the neck more attractive; it won't affect the likeness.)*

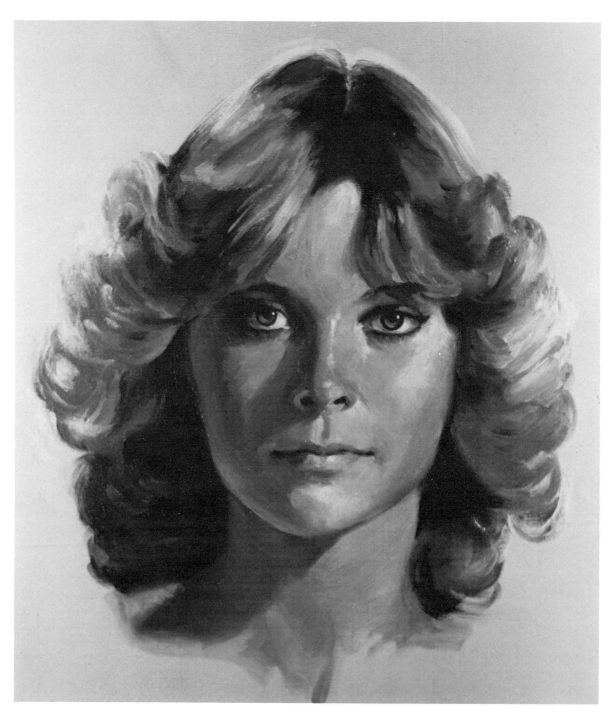

Step 29: When a portrait is almost finished, as this one is, squint your eyes to see its total effect. Are you still aware of paint instead of seeing an impression of flesh, bones, and hair? Better still, is it an image of your sitter? I feel that this portrait is too "painty" and hard-looking. It can be softened a great deal without losing its likeness. I go over the whole face, even the features, to lose their hardness.

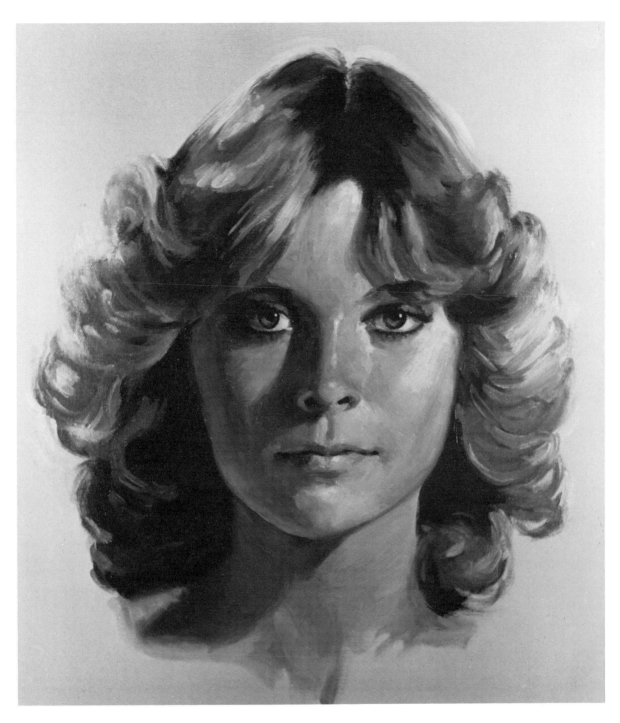

Step 30: I'm still not satisfied with many things. First, there are jumpy values on the left side of the face. The light on that cheek is actually repainted to make the edge of the cast shadow from the nose simpler and softer, and moved slightly to the left.

There's a change in the way the shadow merges into the light along the front of the nose. Notice how I change the direction of that line, making the nose appear more pointed on the end. The highlights on the nose are made more lifelike. The jawline on the right seems too dark, making it look like it is back too far, so I lighten it.

I add still more transitional tones to the hair, especially in the center at the right. Lower down, there are a few strokes added to the ends of the curls. The hair doesn't appear to be supersoft. Instead, it gathers in loose strands and I haven't smoothed out the value changes there too much. I think it still says "hair," but not just very finely textured hair.

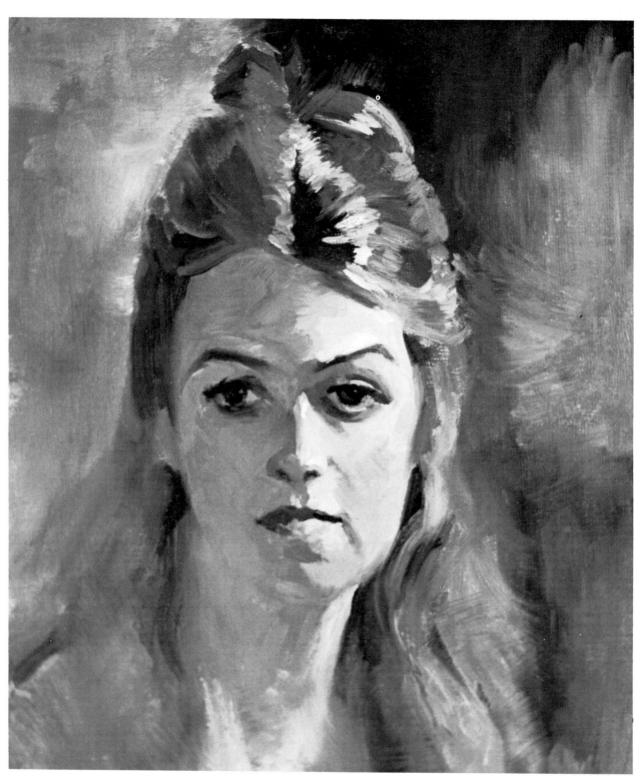

Claire Hart *20 x 16 inches Oil on canvas.*
Collection of artist.
I love to do sketches like this one. Although I'm
not doing a likeness (there's no compelling reason
to do so because I'm not working on a
commission), my instincts and training force me to
try for a likeness.

Demonstration 2

Elongated head

In all of the demonstrations, I've tried to work out a system for painting a likeness—one that's foolproof and logical. But no "system" is completely that. Graphic drawings come close because, as with any transparent medium, you can see all of your previous steps, which act as guidelines. However, in painting with an opaque medium like oil, you cover some of your earlier paint strokes and preliminary drawing. Eventually the basic underpainting can get lost, or even shoved around because you push a little too hard with your brush or move an edge slightly the wrong way.

Even so, it's important to employ a painterly manner, that is, to use enough oils to give your work a rich appearance. Amateurish appearance is often caused by overbrushing the paint. Thin, dry, and brittle paint tends to be almost nasty looking. Put your oils on thickly enough to give your portrait vibrancy and life. Oils were meant to be used in a thick and buttery manner. Warm, light colors especially appear more lifelike when used as thickly as possible. For example, portraits by Ingres, who left no obvious brush strokes in his paintings, have a rich paint quality that gives a radiant glow to the faces of his sitters.

In order to respect the integrity of oil paint and put an ample amount of it on the canvas, you have to accept the possibility that thick paint may cover up your preliminary drawing. Ultimately, you can train your eye to keep you on the track, faithful to your original sketch and intention even after you've completely painted it over.

A system for oil painting shouldn't be too confining. In this demonstration, for instance, the young man has a moustache, so the painting procedure has to be altered somewhat. In other cases, as in the preceding demonstration, the unique light source requires a switch in painting procedure. But even with variations in the steps, you'll always find the same basic system for each painting demonstration.

Elongated head

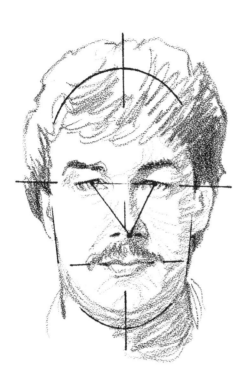

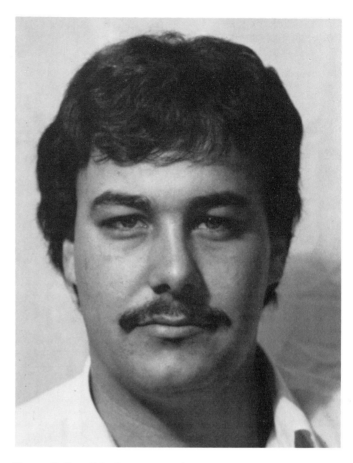

Figure 1: Gregg's head is elongated—an oval with long, flattened sides. The eye line rises a bit on our left while the mouth line goes the opposite way, rising on the right. The best way to demonstrate the relationship of the irises to the nose is to use the triangle configuration shown here, the top left point of it further from the centerline than the right point. At the bottom point of the triangle, notice how the swing to the right shows the underside of the nose at the left of the centerline.

Figure 2: For this demonstration I've chosen Gregg, a young, handsome man with dark hair and a moustache. At first, the moustache might seem to be his most distinctive feature, setting him apart; but with more careful scrutiny you'll find there are other noticeable variations that make him distinctive. As I've mentioned earlier, a moustache doesn't individualize the sitter so much because so many men these days have them and in almost the same style. So you can't rely on the moustache to establish this sitter's likeness. Instead, follow the steps in this painting demonstration closely. You'll learn what else I discovered about Gregg's face that makes it unique.

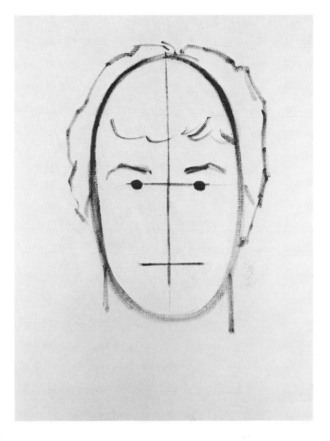

Step 1: In carefully observing Gregg's head, it proves to be a narrow oval. Starting with pure black paint, I'll draw it in with flattened sides. The side on the viewer's left seems a little flatter. I paint in the centerline plus parallel cross lines for the eyes and the mouth. The eyes seem to slant down a bit to the viewer's right.

Step 2: Using a #8 Filbert hog bristle brush I outline the hair, especially the hairline on the forehead. This helps me determine the placement of the eyebrows. These in turn are aids in positioning the irises, which are indicated with black.

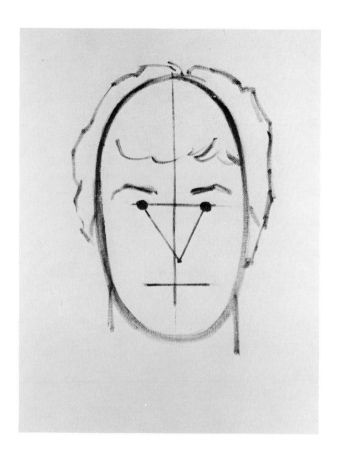

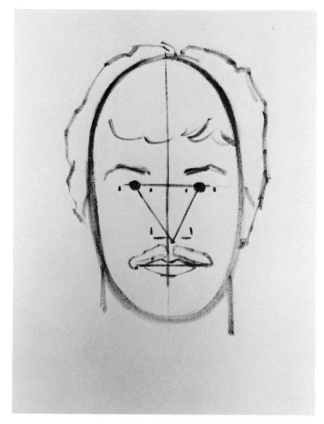

Step 3: Next, I paint in a triangle between the eyes and the nose. As I have mentioned, it's a device that has been valuable for me and I'll be using it throughout the demonstrations. Notice that the point of the triangle under the nose swings slightly to the right of the centerline. Already the triangle is proving its worth by helping to position the features.

Step 4: Next I'll outline the mouth, as well as indicate the outside boundaries of the eyes at the sides. I don't think it's necessary to show the top and bottom boundaries of the eyes, because establishing their width will enable me to estimate their size when the lids are painted in. The nose wings are bounded with small marks, too, and the moustache is outlined.

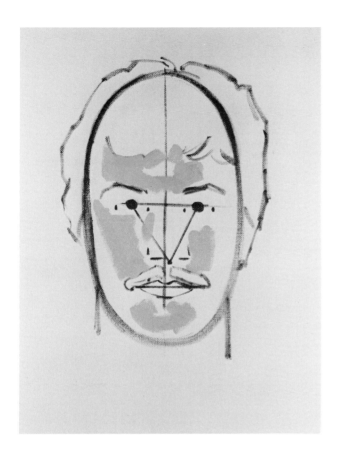

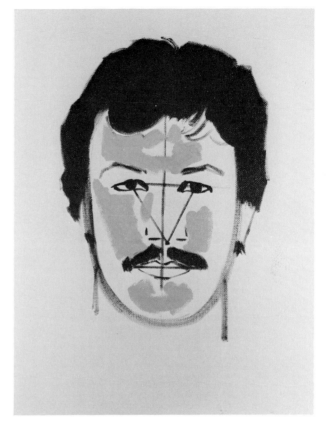

Step 5: Now it's time to start establishing some values. A middle flesh tone would be one that's an average of the values in the light area; on the gray scale, such a tone is about a #3. You'll find in mixing these lighter grays that it's better to start with white paint and add only a bit of black, because the tones get dark quickly.

Step 6: Next I establish the darkest end of the value range. Gregg's hair is mostly black. I scumble in the entire area with black mixture, using a #6 Filbert hog bristle brush. The moustache takes the same dark tone. The irises are made cleaner and sharper now and the lines of the eyelids are indicated in black. The top lines of the eyelids are almost all part of the last line, and rather angular.

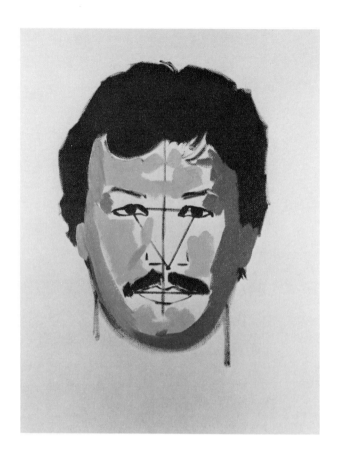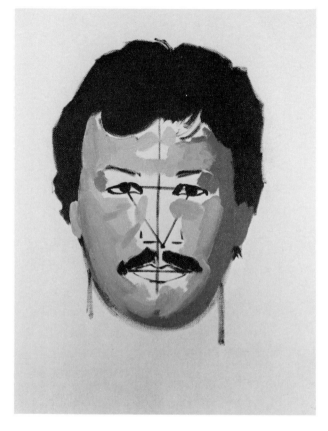

Step 7: Evaluating the tone for the shadows on the right side of the face can be done by noting the difference in tone between the light canvas and the black hair. To me, the shadows look like a gray that's halfway between white and black. The middle tone is used on the side of the chin in shadow and merged into the shadow on the neck. I mix enough of this tone to use later on the neck itself.

The lighter grays that turn the left side of the face are established here, using tones that are between the deep shadows of the right and the first flesh tones. I use these same shades in other places: along the eyes, the cheek, and the cleft of the chin.

Step 8: Now it isn't too difficult to create the halftones based on the dark shadow tones and the lighter ones. Making the transitional values that occur down each side of the head comes next. On the left, these tones start to blend into the darker paint.

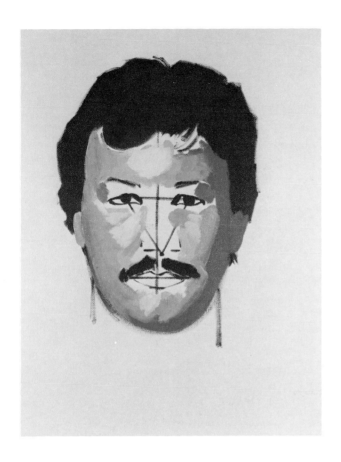

Step 9: The large highlight areas on the fore-
head, the cheeks, and the chin are made by
using almost pure white with only a touch
of gray. The angle of the cheek on the right
slants back away from the light just enough
to be a mite darker, though it's still in the
family of those highlights.

Step 10: I don't like to leave the neck un-
touched for too long before working on it, so
here I establish its small basic light area. Us-
ing the paint already mixed for comparable
tones on the face, I paint in the neck's large
cast shadow on the right.

Step 11: Although I've stressed in an earlier part of the book the importance of eyes to achieving a likeness, in this demonstration I'm working out the structure of the nose first. The eyes are still important, but the eyes and mouth both depend on the nose to establish their location and dimension. The triangle configuration is used to establish the nose's length and width, then the line of the nose can help determine the width of the mouth, the corners of the eyes, and even the irises. And it's the structure of the nose that allows me to precisely check the position of all these features.

Step 12: To develop the eyes, a light tone above the lids is painted in lighter on the left side, and then a small dark tone over the eye on the right. The black of the deep shadow is brought farther over the right eye and "window" lights (whites) on each side of the irises are indicated. Notice carefully their different values. The "white" in the corner of the eye on the right is the lightest. Each tone beside the eye on our left seems to be the same. The tone in the white of the right eye on the shadow side is darkest and blends into shadow.

I paint in a large stroke underneath the eyes for the puffy part, and then over the top of that make a shorter, lighter stroke on each to round them out. When putting in the whites of the eyes I stroke up and down, which means that I'll obliterate some of the lid lines. Now's the time to go back and restate those lines, as I have here. In doing so, I've made the lower lid line on the left eye a lighter gray than its first black outline; the right eye doesn't show any line.

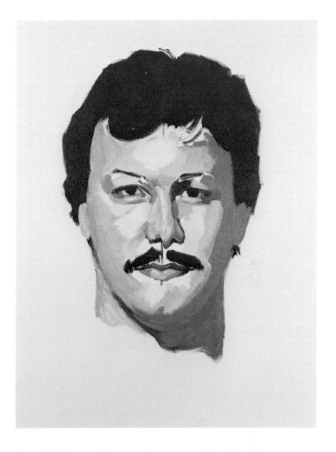

Step 13: The mouth is painted, using a darker value on the upper lip with a touch of lighter gray along the center. The same thing can be done on the lower lip but the values are higher. I then paint a dark line that separates the two lips clear across the mouth, making the line heavier in the corners. For these mouth and lid lines a small pointed sable is used.

Step 14: Returning to the nose, I develop the basic planes established earlier. A darker value is painted down the length of the right side. It cuts in to straighten the nose, joining the deep shadow above and extending down to the wing. While looking at the side, it is apparent that the top part of the wing needs to be a little lighter, due to the reflected light from above. The nostrils have lost their proportions—their elevation is wrong—so they must be corrected. On the left, the wing is slightly darkened from the depression of the cheek as it runs down to the nostril. I develop the tones on the bridge between the eyes, then paint the broken highlight down the nose's front with pure white.

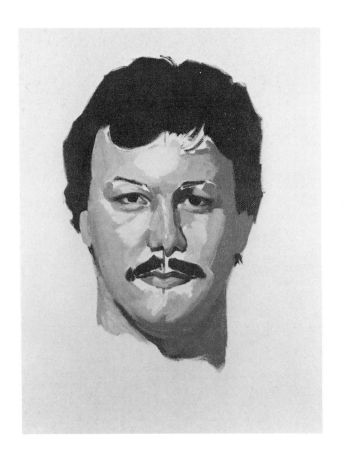

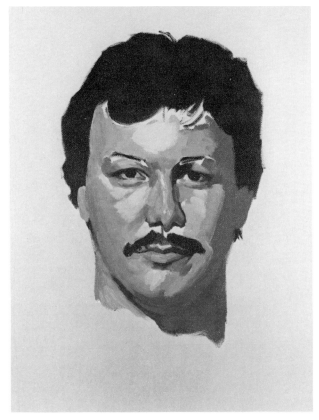

Step 15: To see what has taken place in further development of the eyes, refer to Step 14, carefully. The changes are subtle, because now I must bear down and be more precise with my draftsmanship. First, notice that I've cleaned up the irises, that is, made them more precisely round. The one lid that shows on the left eye in the corner is drawn carefully. The puffy parts beneath the eye assembly are molded and softened. Notice that at the extreme left I've covered up the little dark gray line going to the lash and extended and softened it. A halftone is added above the left-side eye socket. Then with a dry brush or fan blender, I soften the top lid line over both eyes.

Step 16: Returning to the mouth, I develop not only it but the structure surrounding it as well. Four close values shape the lower lip and turn it outward. I leave these tones in a rough state and wait to finish them. The values directly above the upper lip are blended into the moustache on the right side, but on the left these come down into the lip itself to soften the edge.

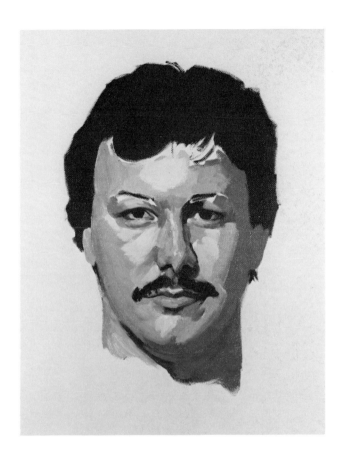

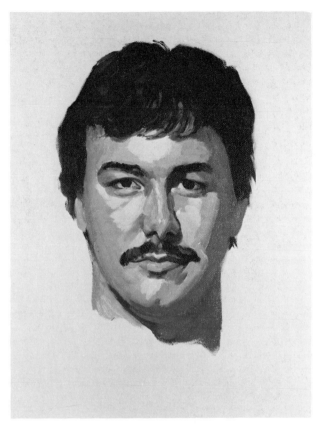

Step 17: *There comes a time when the white of the canvas is a hindrance to determining correct values. The unpainted area between the mouth and nose is a good example. To overcome the problem, I block in some tones there. One stroke placed on the left is very light. Then alternating dark and lighter tones are added that darken overall as they move toward the shadow on the right, by the nose. That shadow is almost totally black.*

Notice how the very light flick of paint on the upper lip immediately becomes brighter because the competing white of the unpainted canvas is now covered.

Step 18: *The bare canvas around the eyebrows and the forehead is now covered. Black is used for the eyebrows and the hair that falls down on the forehead. A lighter value is blended into these areas, as well as the edges. However, in this step I allow the mixture of values to blend in the eye of the viewer rather than blend them very much with my brush.*

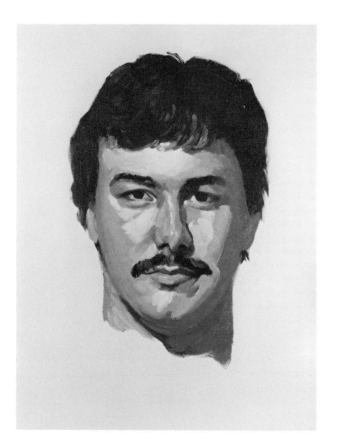

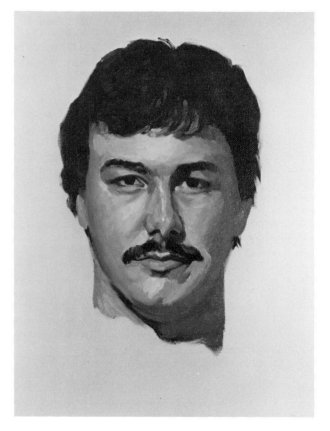

Step 19: Continuing to concentrate on the forehead, I add tiny amounts of gray to the light value mixed previously for the highlights. (I avoid adding black to this light mixture, because it will darken too rapidly.) With a clean brush, I pull this new gray value into the light area of paint on the left of the forehead, allowing the paint to blend itself rather than overworking it. If the new tone darkens in this pulling-blending process, more of the tone used for the highlights can be added to lighten it. I work on both sides of the forehead in this manner, right over to the shadow tones and hair, leaving this step in an incomplete state.

Step 20: Moving down the face, I paint across the cheek area, using the same technique described in Step 19. Here, however, the values are darker than on the forehead. I constantly refer to the forehead area for comparison of values. The only area of the cheeks that has the same value as that of the forehead is a small area on the left side. The values on the right cheek darken as they merge into the shadow on the side of the face.

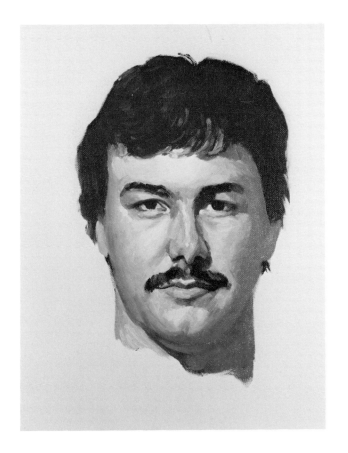 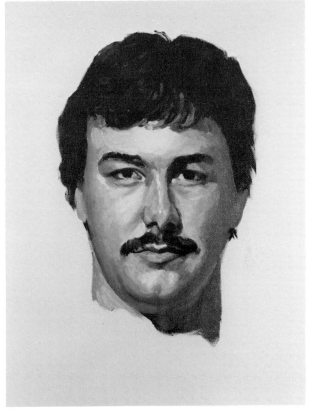

Step 21: The values around the chin are now softened, and the drawing of the chin is corrected. Note that I've defined the jaw on the left and brought it down somewhat. The indentation on the chin is brought out by placing a light spot opposite the highlight on the chin. Then the dark halftones that show the cleft of the chin are blended further, along with the values under the mouth and on the right into the shadow.

Step 22: I continue to work on the chin. The main thing this step accomplishes is to bring the jaw down farther to follow the contour of the neck. The light areas on the neck are darkened and the shadows there are lightened up.

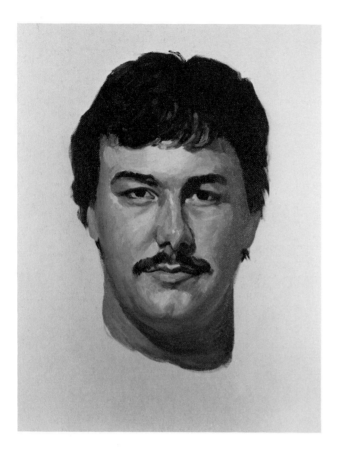

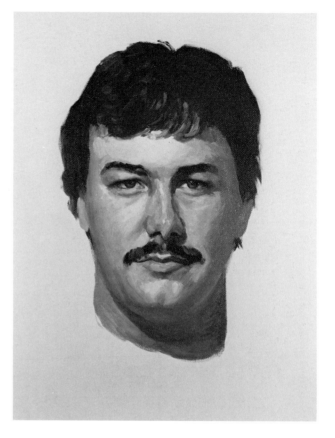

Step 23: Here I add some paint to the neck and bring it down lower on the canvas. Curving strokes that follow the contour of the neck are used. I continue to darken the light areas on the neck and to further lighten the shadows.

Step 24: Now I begin to refine and finish the features. It's time to zero in on the eyes to achieve a faithful likeness. The irises are catching the light. Until now I hadn't noticed that the overhang of the lid on the left eye blocked out light from the main light source. But that eye catches some light from a secondary source positioned farther back on the right. That reflected light makes it appear that there's an unusual turn to the eyeball when in reality there isn't. This light pattern must be conveyed exactly as it appears in order to capture the sitter's distinctive gaze.

Additional work in this step consists of painting in the color of the iris and blending all of the values around the lids, the whites, and the pouches. The tear duct corner of the eye on the left is raised a wee bit. The lid next to the shadow side of the nose is accented. The cast shadow of the lashes on the right is also defined.

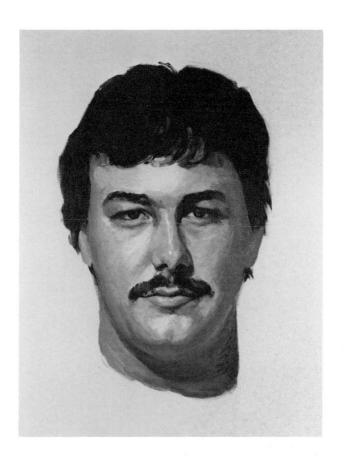

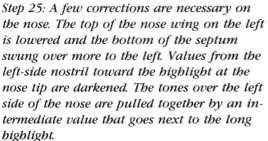

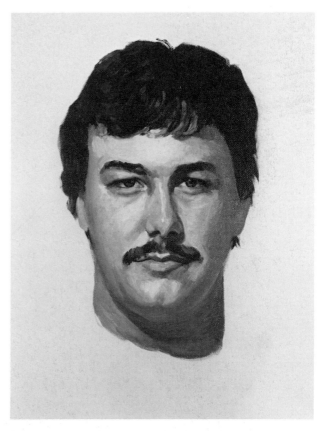

Step 25: A few corrections are necessary on the nose. The top of the nose wing on the left is lowered and the bottom of the septum swung over more to the left. Values from the left-side nostril toward the highlight at the nose tip are darkened. The tones over the left side of the nose are pulled together by an intermediate value that goes next to the long highlight.

Step 26: The mouth is completed in this step by merging tones already laid down. The peak of the upper lip on the left is raised a bit. The angles of the separation line are flattened because they are too exaggerated. As I blend values I also curve the lower lip on the bottom and deepen it on the right. Finally, I add the barest suggestion of shine with a little white applied in a wiggly fashion across the upper third of the lower lip.

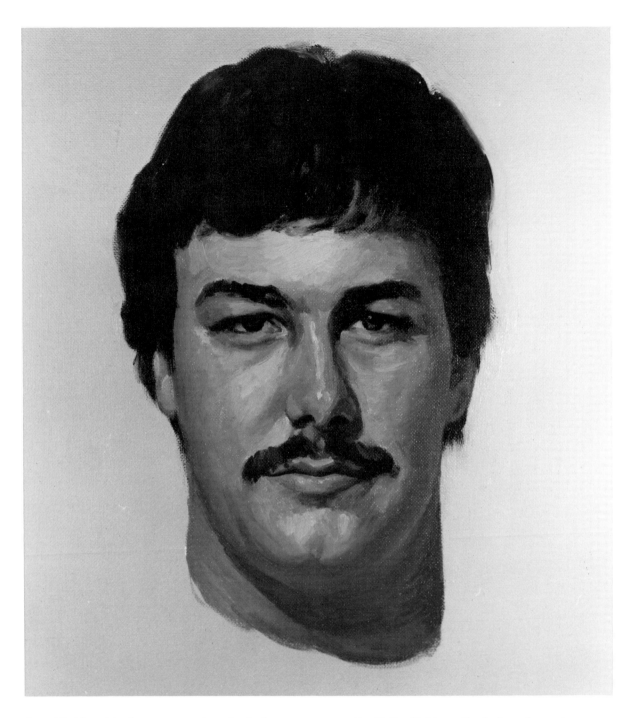

Step 27: Now it's time to attend to the hair, especially its periphery. As the edges are softened, its shape can be refined. The main thing to consider is how the head influences the hair's shape. The details of the individual hairs aren't important.

I add the light on the hair, using a tone that's very close to black. A little correction is made where the hair comes onto the temples. Then the sideburns are more carefully drawn. The edge of the hair that hangs down on the forehead is blended even more.

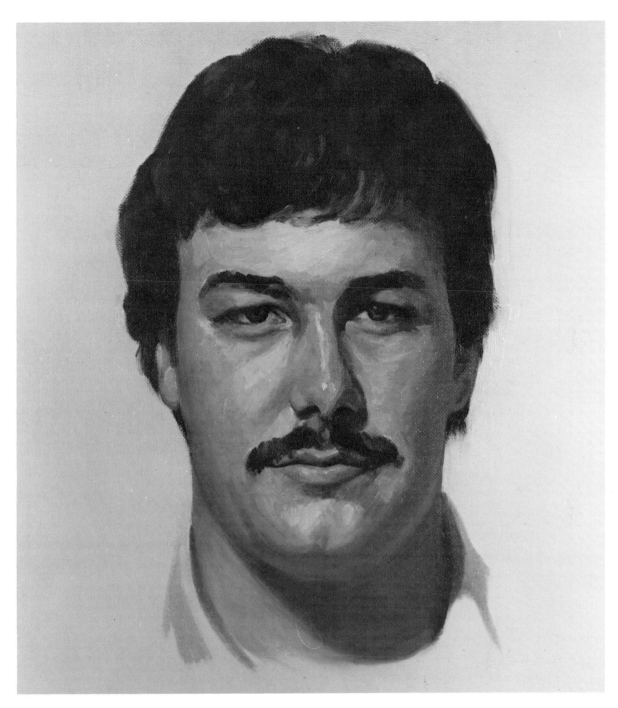

Step 28: Now the neck is refined. The light on it seems too dark, so I bring it up one step in value. I cut in a darker tone underneath the chin where it meets the neck. That dark tone is blended evenly down into the shadow, making that area softer. A suggestion of shirt with some dark separations completes the neck.

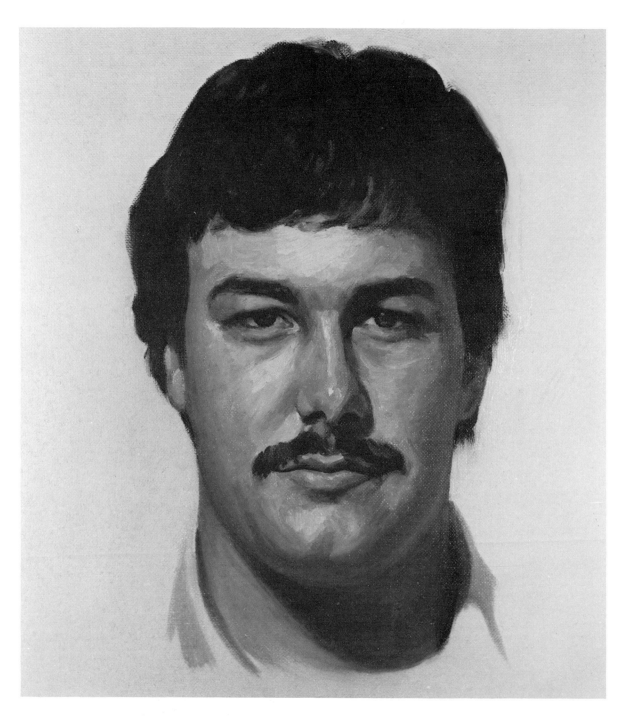

Step 29: Now I go over the entire face and pull tones together. I leave them somewhat brushy, allowing the values to blend more in the eye of the viewer than on the canvas. When all the paint is wet, you can brush and blend tones together easily. But during the time it takes to complete this demonstration some paint gets too dry to blend, so I couldn't make the tones very slick even if I wanted to, and I don't.

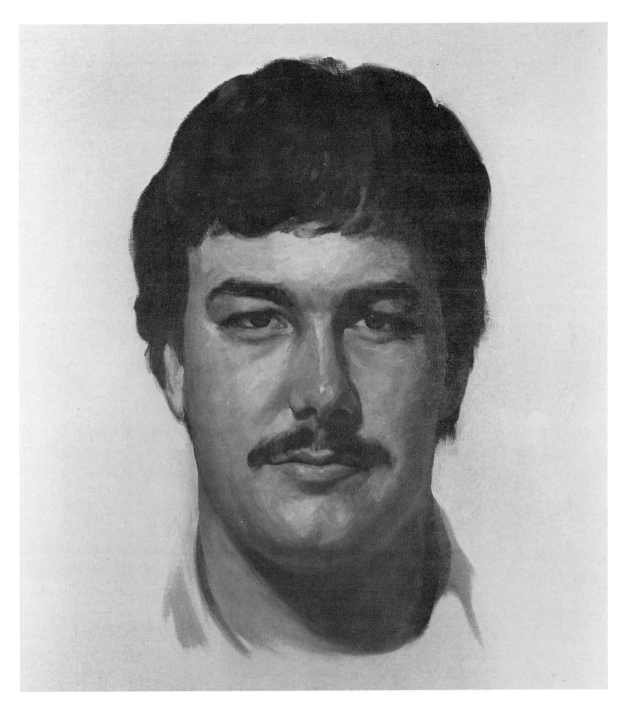

Step 30: The last thing I do is soften the moustache. I leave this until last and substitute it for the step in which I usually do a bit more to the hair, as in a woman's portrait. Since there isn't much more to do with this sitter's hair, this final step can be used to refine the moustache and finish off any other unfinished areas.

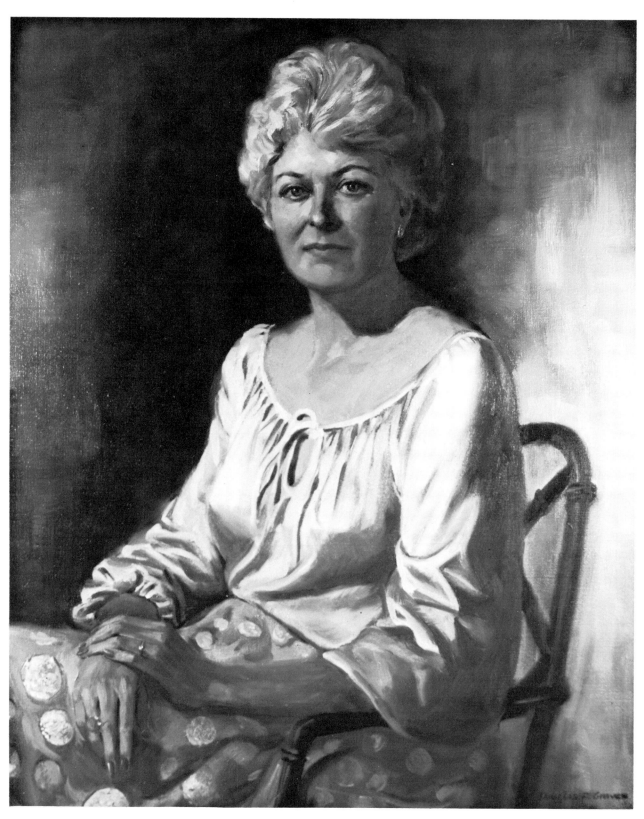

Mrs. Thomas Meagher *30 x 25 inches Collection of Mr. and Mrs. Thomas Meagher.*
I painted this portrait from life. Whenever possible, I prefer to work that way. In this case, however, I did have photos to use as substitutes, in case the sitter's schedule prevented her from posing.

Demonstration 3

Square-shaped head

This demonstration will present a new challenge in three ways: the head's shape and position are different; the sitter is smiling; and her features are more petite than those of the two previous sitters.

To find a way to cope with the problems of proportion, so important to a likeness, let's use once again the comparison of a portrait to an intricate puzzle. If you can picture the sitter's image flattened out (as in a photograph) and then cut into large pieces, each of those pieces can then be fitted together to make a simple jigsaw puzzle. These large pieces might consist of such shapes as the head, the general shape of the hair, and the neck.

Now imagine each of the large pieces cut into smaller ones. For example, the shadow areas within the hair could form small pieces of the larger hair mass, and the garment on the neck could be a piece of that larger neck shape. The entire portrait can be conceptualized in this way, right down to the smallest dot for the highlight in the eye.

Obviously, if the largest pieces aren't correctly shaped, then the next smaller pieces within them won't fit properly. If all the large and medium shapes are correct, the painting becomes progressively easier, because there can be only one correct place for any of the smaller pieces.

Of course judgments must be made as you progress through the painting, about the various colors and values to be used. You can use a deductive process for this; once you've established the range of values—the darkest, the middle, and the lightest tone—the subsequent values can be compared to them. As you move through the painting, basing each step on the last, you're constantly adding more values that help to evaluate the ones that follow.

Square-shaped head

Figure 1: There's a squarish shape to this face, but you don't notice it as much as you would in a complete straight-on pose, because the head here tilts back and turns away slightly. The features line up fairly well except for the nose, which rises to the right side, while the point of the chin swings to the left. The center vertical line appears curved outward because of the head's angle. That perspective also causes the mouth and chin to appear to recede, which places them left of the centerline.

Figure 2: Beverly is an attractive, vivacious woman who is known and remembered for her smile. The smile is a natural and customary part of her countenance. Very often, a beautiful smile is as much a part of a person's likeness as the features. When smiling, the mouth changes its shape, and this affects all of the other features. The eyes squint and crinkles form at their corners. Creases form on the cheeks down from the nose, as it wrinkles a bit, too. The teeth must be considered, as well.

In this demonstration, in addition to painting a smile, I'll also explain ways to test your powers of observation. Note that Beverly's head is not only turned but tilted back slightly, which makes the vertical line somewhat curved. That curve causes the lips and chin to appear to be off center.

In painting the teeth I'll deviate a bit from the photograph. This is a liberty that is always open when painting teeth. It won't affect the likeness. In fact, it will improve the painting.

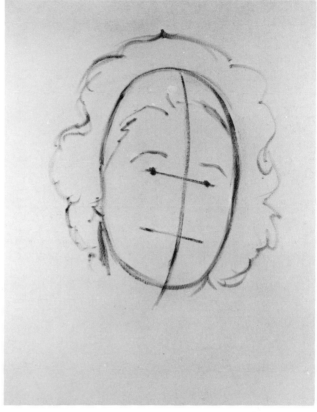

Step 1: When the head is turned at an angle, it would seem that the rules we relied on before would be useless. Not so; it's just that the pieces of our portrait puzzle now have slightly different shapes because of the change from a straight-on view. For instance, the oval of the head becomes more bean-shaped and the side curve of the face comes into view. The center vertical line becomes an arc. In this step, I establish the head shape with a light outline. The lines for the placement of the eyes and mouth slant down to the right.

Step 2: You may wonder why I don't recommend using a tighter charcoal or pencil drawing before beginning to paint. Since I prefer alla prima painting (a bold, brushy, direct procedure), it seems wasteful to do a tight outline, only to cover it up quickly with thick paint. In this step, I vaguely define the large pieces of this portrait puzzle: the hair mass, hairline, pupils, and eyebrows. Remember, although you're thinking about this portrait as a puzzle, you must allow yourself a certain amount of freedom or your portrait will become just a "numbers" painting, mechanical and lifeless.

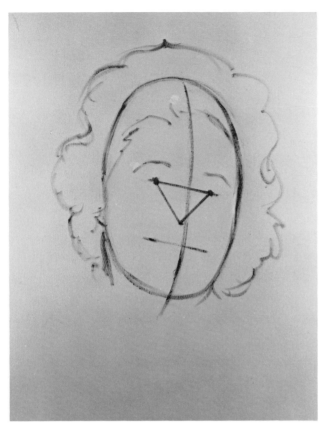 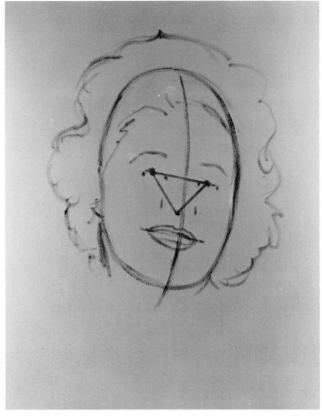

Step 3: Here I introduce the triangle to help place the nose. Notice how the positions of the features are different in this portrait because of the angle of the head. The eyes recede into the head and the right eye moves close to the centerline. Also, the spot under the nose moves from that line, because it's set back under the nose. The tip of the nose is one point of reference along the vertical line, and it begins to push out. The profile and three-quarter views in Section 4 will show these relationships even more clearly.

Step 4: Because of the angle of the head, a large part of the mouth appears to the left of the vertical line. When we think of the head as a puzzle with interlocking pieces formed by the features, we visualize its flat aspect and compare the geometric shapes of the features to each other. In that way, we can line them up across and up and down the canvas and estimate distances between them. But now, think of this head in three dimensions. Test the proportions of the flat puzzle technique by also thinking of the head and features in their three-dimensional form. These two ways of conceptualizing the head provide checks and balances for each other.

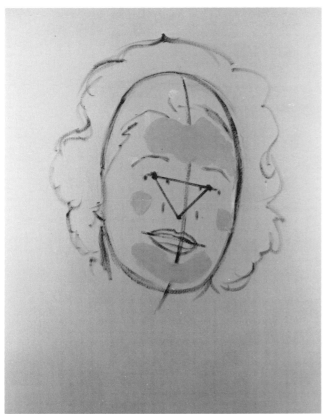

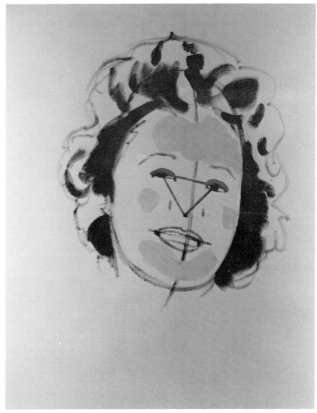

Step 5: I enjoy dipping into juicy paint with a large brush and painting in the large masses. I start the basic flesh color areas on the forehead, both cheeks, and under the chin. They're slightly darker than the canvas, about a #1 gray.

Step 6: In any procedure, the next step is to establish the darkest tones. Dark areas like the hair should be made with an ample amount of paint; I don't paint in all of the hair, but the amount I've done supports the feeling of dark hair masses. I add small bits of another dark value to the eyelids.

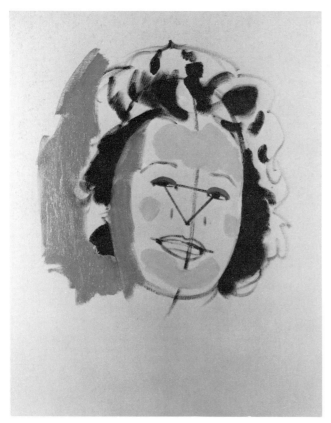 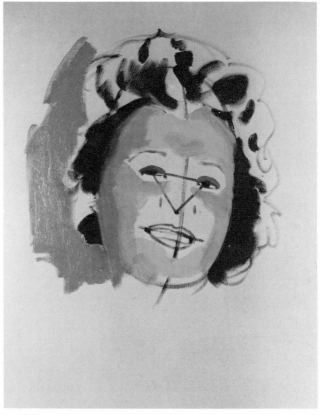

Step 7: Now the middle tone is added on the left side of the face in shadow. I can use that same gray for the background, because I've mixed enough of it. Filling in the background on the left gives the effect of side light on the hair. Any time you can get an impression of the final picture, it's good to do so, because it encourages you to continue working.

Step 8: The volume of the head becomes apparent when you add the halftones. They're just flat areas of tone on the cheeks extending under the eyes, on the forehead, and on the chin. But they all help to thrust the front of the face outward. Those tones are fairly evenly distributed on each side but come across the top plane of the cheeks, since the light source is low. Even the forehead on our left side angles back, making it darker.

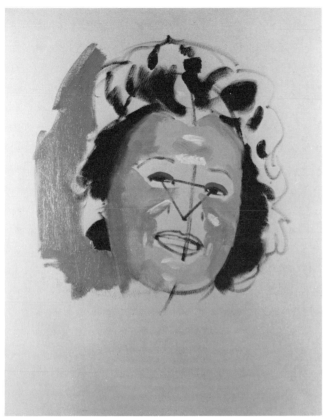

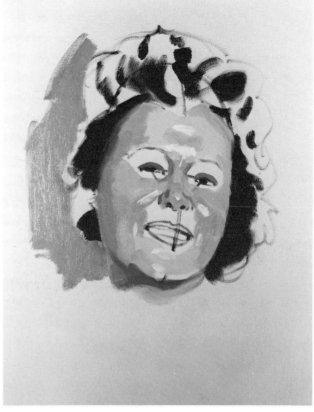

Step 9: Now's the time to add the extreme light tones. Big dabs show either prominences or highly reflective places like the forehead, across the bridge of the nose, on either side of the nose wings, and below the mouth. You can see how useless a tight outline would become at this stage. Dabs of paint don't have to have exact contours, because they mainly serve to establish the values. But the underlying drawing isn't completely lost; with new paint strokes, I'll soon reshape the main features.

Step 10: Now I'll start to establish a rough indication of the likeness. The nose is blocked in, with attention paid to its position and structure. Notice the upward tilt to it on the right. I like to use healthy amounts of paint at this stage.

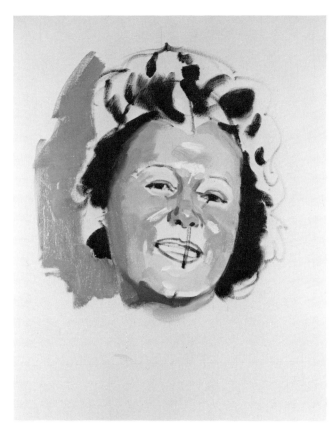 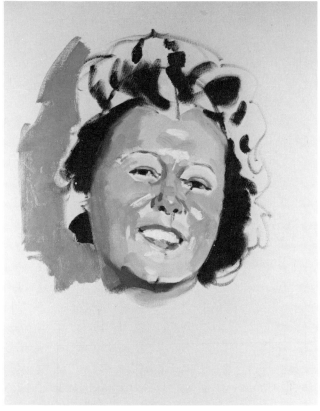

Step 11: The same kind of work is now done to the eyes. The four values of the whites of the eyes are established here. These tones are important because they give a three-dimensional quality to the eyeballs and help make the eyes track properly.

Step 12: The mouth is a simple shape and I work on it now to bring it to the same stage as the nose and eyes. First, I paint the values around the lips to show the basic shape. I use these same values for the gums. The teeth follow the same roundness as the flesh that covers them. I block them in with pure white, which I stroke on vertically. This gives the effect of teeth without really delineating each one. Over the teeth I paint the lips. The top one is almost one sweep of a #5 gray, although a small part on the right is a little lighter. The bottom lip is broken into three planes, with the center section a #3 value.

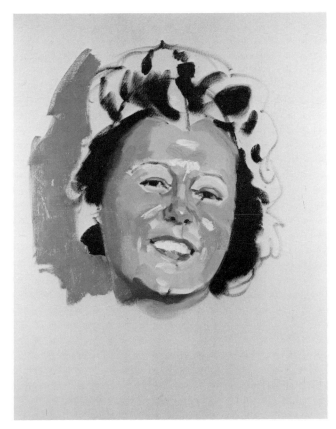

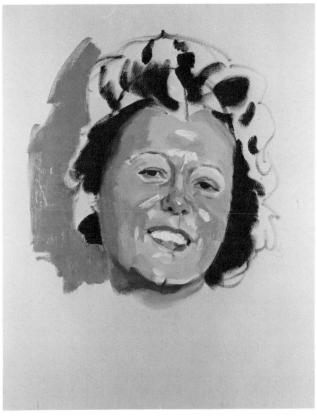

Step 13: Now I lay in the values between the mouth and nose. These tones are very light and closely related. They must show the thrust of the bone underneath. The nose begins to come forward in this area and the mouth and teeth become more round. The correct tones and their proper placement are vital in establishing the outward projection of the face and the features.

Step 14: Seemingly insignificant areas around the eyes and nose can help to establish a likeness. Here I develop these areas. Notice that the pouches under the eyes are added, as well as halftones just below that help mold the nose and the cheek.

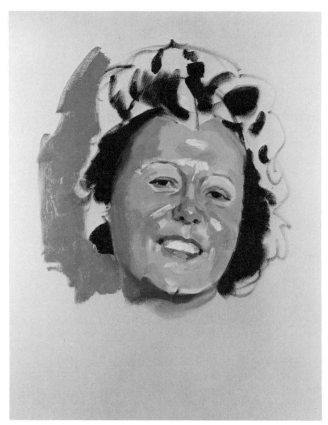 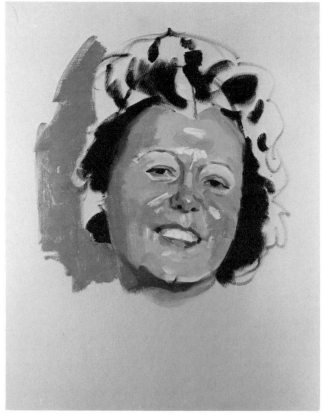

Step 15: The mouth now lags behind in development, so at the corners I add tones that turn it in. The one on the left corner is a bit darker than the large tone above it. I reestablish the blackness in the corner of the mouth on that side also. The teeth now need to turn a little more into the dark, so I do a bit more vertical brushing with gray. The roundness underneath the lip is achieved with a middle tone on the left, a lighter one in the center, and then a much lighter tone under the lip at the right. That portion catches the light quite brightly. The right corner of the mouth spreads a little too much, so it is brought back into shape.

Step 16: More tones are placed between the nose and mouth. From the left corner of the mouth, there's more of a gradual transition. A middle value goes along the top lip and widens into the cheek. Its upper point falls directly under the pupil of the left eye. On the opposite side, I paint a gray that's a continuous tone from the corner of the mouth up to the nose. It covers most of the previous darker color but is replaced with a small flick next to the groove in the upper lips. The vertical guideline is now completely covered with a white, curving, spear-like stroke from the nose down to the top of the mouth. To the left of it is another curving stroke of a #1 value. Notice its tilt; it lines up with the inner corner of the eye on the left, and the bottom of the largest tooth on the lower right.

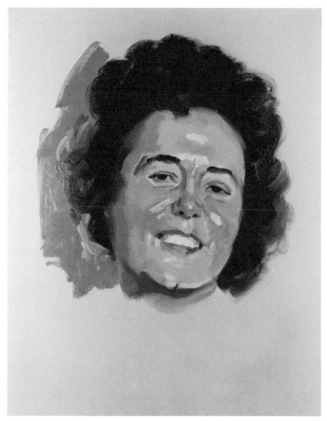

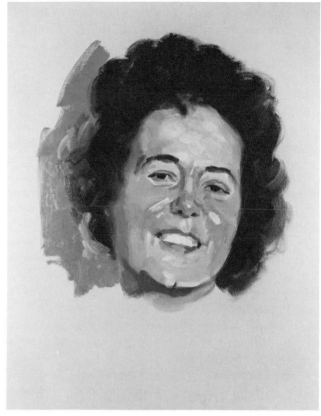

Step 17: Now I unify the mass of hair to resolve the range of values on the whole head. Although there are enough keys for the dark end of the value scale in the hair color, I need to paint the total mass to correctly determine the tones in the face. After the hair is painted, the facial tones appear rather light. The hair also provides positioning elements among its border with the face. For instance, the lock on the forehead should line up with the left edge of the nose in relation to the right point of the chin. Where the hair ends on the left side of the neck helps in determining the exact length of the jaw. To finish this step, I roughly blend the hair into the shadow to show evidence of the side light.

The eyebrows are painted to show their changing shape and values. The left brow seems darkest and heaviest. I must be careful where I place the eyebrows' inner corners; they will influence the position of the eyes.

Step 18: Now I can develop the forehead further. The bright stroke in its center is widened. This stroke is part of another light tone underneath, touching the arc of light on the brow below. Notice my correction of the angle of the area that turns into the temple. Instead of turning in a perpendicular manner, it now angles toward the right, the sharpest edge pointing directly toward the corner of the eye on the left. The plane from the front of the forehead to its side angles in, then abruptly angles out again; then finally makes the corner into the side plane. On the upper right of the forehead, three spots of light bring out the prominences of the skull. I restate the part of the eyebrow on the left temple that I've painted over in preceding steps.

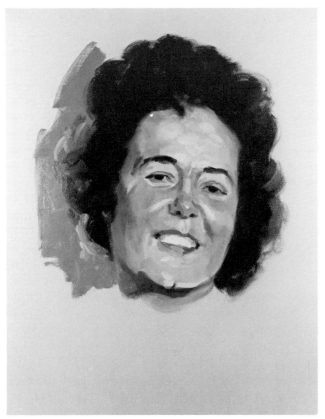 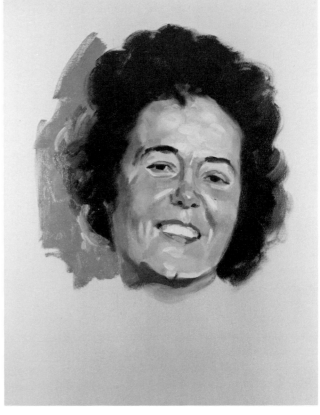

Step 19: The cheek area is developed here. On the left, notice the direction the top of the shadow takes as it turns; its angle is identical to the one at the temple. A second light plane is between that shadow and the region under the eye. It's a number #3 value, whereas the shadow is a #5. That #3 tone is used also on the right-side cheek, directly under the eye. It wipes out the little dash above and, when mixed with a #1 value, connects it to the nose plane. The two brilliant highlights on the cheeks are faded off into the surrounding colors and the crease of the cheek is begun. As it forms, it curves counter to the one above, next to the nose. Notice its position and the direction it takes. It will be instrumental in keeping the width of the mouth correct.

Step 20: I not only smooth out the tonal transitions in the muzzle region, but also indicate the character lines on each side of the mouth. They're composed of three almost pure white downward strokes, two on the left and one on the right. I sight between the jawline and the eyes above to position those strokes correctly. Next to the two strokes on the left, the turn of the cheek continues and meets the shadow above, although it's lighter. Very subtle planes flare out directly under the lower lip. The one on the left goes down to meet the chin. Both planes are a #2 gray.

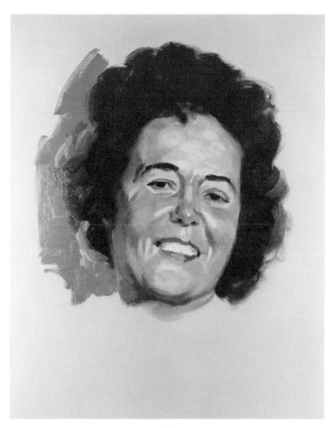 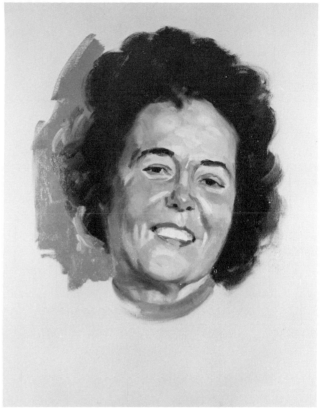

Step 21: Although it doesn't look right now, the whole chin arc has to be swung to the left, because of the change in perspective caused by the angle of the head. Later in the portrait, this proportion will look natural. The left edge of the chin falls directly under the little nick in the blackest of the eyebrow on that side, while the right edge of the chin ends below the nostril. Also, the left point is much higher than the other. I resist the urge to level those ends, so I retain the chin's proper tilt. Another, larger arc like that of the chin forms the jawline. Even though it's roughly painted here, its position and curve must be considered carefully because it influences the whole head. On the left it rises to meet the edge of the main shadow. The chin and jawline are fused into tones above.

Step 22: Here I start an indication of the sweater. All that's necessary is to paint enough of it to establish the end of the neck tones. In this step, I rough in the main shapes of the neck as a matter of construction. Although it's not necessary to achieve a likeness of the neck, I do have to paint its construction correctly. For example, the light on the right that turns down to the sweater must be accurately placed.

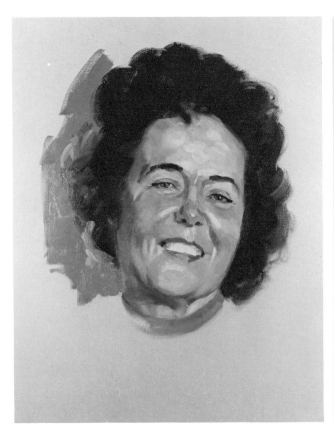

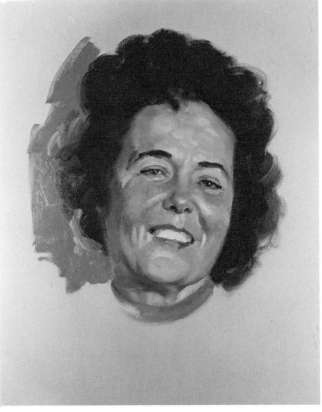

Step 23: Before the irises are painted, it's important to check the form of the eyes themselves. The lid on the left should be deeper. But instead of raising its top line to accomplish this, I close the eye a little more. This produces the same effect without losing the eye's basic construction.

I carefully shape the areas underneath the eyes, between the sockets and the cheekbones. The skin there covers the lower part of the eyeballs, gently following their curve. There's a crease to the left-side eye where the flesh sinks in between the socket above and the covering of the eyeball, forming a continuation of the cheek's roundness. Also, two little flips of paint in that area produce the beginnings of laugh lines that give Beverly's eyes that happy sparkle.

Step 24: Here I evaluate the nose's structure to determine if any changes are needed. One little brush stroke on the right that has been a delineating line seems to impart the feeling that the tip isn't wide enough, so I cover it with a light value. The other side of the nose needs to be at more of an angle; the nostril is flared out just a bit more. All of the cartilage around the nostrils needs rounding and shaping. At the same time, it's essential to maintain its original construction. If my brush squishes out too much I could change an edge, which would alter the nose's appearance quite a bit. For better control, I use the small pointed sable brushes here. I'm careful to retain the position of the nostrils; they tilt up to the right and create a distinctive part of the sitter's likeness.

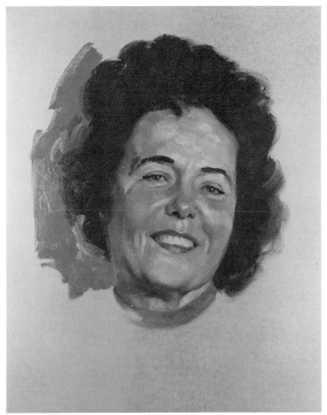 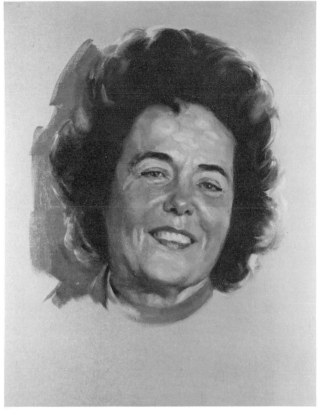

Step 25: Studying the mouth, I find that its upper lip isn't deep enough, but the line on the top left of it is just right. Judging the mouth's depth from that line, I paint more of the teeth. I correct the top edge of the mouth by adding a lighter color at the right and stepping up the value of the flesh above. This gives a softer appearance to that mouth. The edge at the top of the teeth needs to be cleaned up. The lower lip needs work mostly on the left. The dip in it is brought out more to the left and the whole front is rounded with gradual values.

Notice how the barrel-like shape of the teeth is emphasized, noticeably on the left. But again, I don't define the teeth's separations; instead I merely suggest them by showing the gums between the tops of the teeth. The separation line from there down is left to the imagination. This is a case where it's more flattering to suggest the presence of a structure rather than actually show it. A dot or two of pure white on the teeth adds spar-

kle to them. The lower edge of the teeth that meets the lips isn't hard; it has an accent in the center where the lower lip dips and leaves a tiny opening.

Step 26: Now, what's lacking is a little more of the garment. It will bring the background into the lower part of the picture. Also, the attitude of the left shoulder and neck isn't clear unless the jacket comes around the neck from the back. By sighting across the face, you can determine where it emerges. It appears to be halfway between the mouth and the chin. Where the jacket drops also helps determine the width of the neck.

Step 27: At this point the painting has established a likeness of Beverly. The technique has a little bravura without sacrificing draftsmanship. The attitude of her head is correct; the drawing is solid; the features are cohesive and show her expression. She's a brunette with a cast of light on her hair. However, some painters wouldn't be comfortable leaving the painting at this stage of completion; they'd need a more finished rendering. That's a legitimate decision. To achieve that further degree of refinement, one must simply continue to pull together all the tones and sharpen some of the edges. I'll continue in that direction in these next three steps, and I'll start here by smoothing out the tones on her forehead.

90

Step 28: If more refinement is desired, you can smooth out the tonal values of the cheeks and make them more subtle. I do this mostly on the front where the larger tones frame the cheeks. The highlights are also toned down. But I don't do any additional work to the shadow, because its shape is correct and it doesn't jump out. I'm satisfied with it, but if I wanted to make it look slicker, a more opaque tone there would do it.

Step 29: Since I've refined other parts of the face and head, the rough painting of the neck now stands out too much. Originally the painting of the neck consisted of tones placed to establish structure. Simplifying the values on the neck makes it recede and it isn't as noticeable.

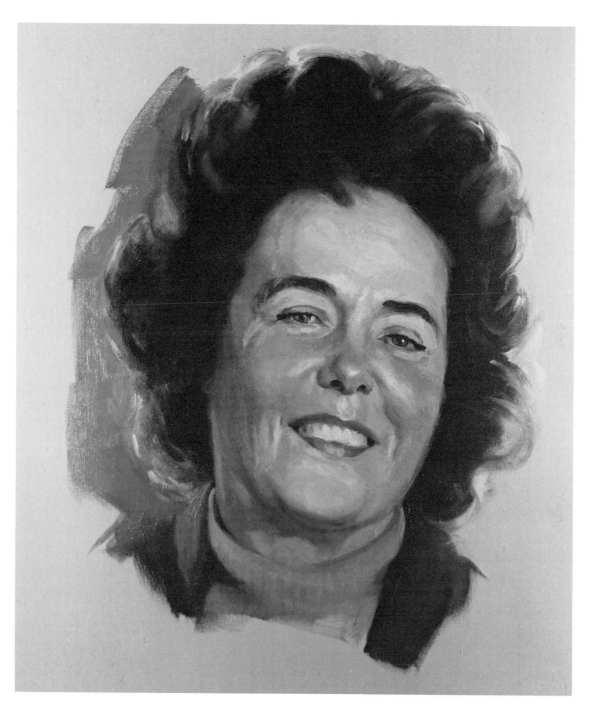

Step 30: Having completed everything that determines the sitter's likeness, I'd like to stop. But there's always the temptation to do a little more. So I add to the suit and sweater. Also, I feel compelled to add a couple of swirls to the hair, on the right side center. The lower part of the hair on the right gets additional strokes that lead into the garment. Then I force myself to lay down my brushes.

Section 3

Working with Color

Introduction

Color is important to achieving a likeness when painting the skin and hair. But it's impossible to reproduce exactly the color of flesh with paint; the best you can do is create the illusion of skin color and texture.

If you're working from a color photograph you're further handicapped, because the chemicals in color film create an interpretation of skin color, not an exact reproduction of it. Even a high-quality photograph will stress some colors while omitting others. When you paint from life, you can evaluate more precisely the color of the sitter's skin and hair but you still have to approximate those colors with paint.

In Andrew Wyeth's portraits, the flesh tones, if examined closely, reveal tiny spots of slightly different tones of closely related colors that come very close to matching the tonal changes of color on the faces of his sitters—right down to the color of freckles! At the other extreme, Van Gogh's self-portraits are a mass of short, stabbing strokes (all about equal in length) of widely different, brilliant colors. Van Gogh, no doubt, intended these different colors to mix in the eye of the viewer and convey the impression of flesh and facial colors. Other portrait painters may not be as daring in their approach, but still use palettes that only suggest facial tones rather than try to exactly reproduce them. Obviously there is no single formula for painting portraits in color. This allows you a great deal of freedom to express yourself while capturing another's likeness.

The colors I recommend are just a few of many possible palettes. My colors are high-keyed and clean, and you don't need a complicated set of rules to mix them. Use this palette as you begin, then experiment with other color approaches if you aren't satisfied. In the bibliography I've listed books on color that offer other palette possiblities.

No matter what palette you choose, you must first establish a strong drawing and controlled values in order to render a convincing likeness. Color can be the outlet for your creativity if you feel that these two art fundamentals—solid craftsmanship and control of values—are restrictive.

Color Demonstrations

Materials

Having completed the black-and-white demonstrations in Section 2, you already have titanium white, ivory black, and possibly burnt sienna on your palette. To those colors now add:

> cadmium yellow medium
> cadmium red light
> yellow ochre
> thalo red
> light red
> thalo red-violet
> burnt umber
> thalo green
> viridian green
> ultramarine blue

I'll use the same brushes for these demonstrations as for the black and whites, but I have twice as many of the large ones. The reason is that there should be a pair of each size brush, so that you use one brush for the high-keyed colors and the other for the lower-keyed ones. For instance, you wouldn't want to use a large brush that has burnt umber on it for the light, warm colors in the face. This may seem obvious, but it's a great temptation to just try to wipe off a brush and pick up the next color with it, regardless of what that color may be.

As I mentioned in the black-and-white demonstrations, I don't advocate use of a medium, and that includes solvents like turpentine, etc. These not only ruin the color of the paints by thinning them out, but they also make your brushes dirtier, because the solvents seem to make the pigments sink even further into the bristles of the brushes.

Color Demonstration 1

Young, blonde woman

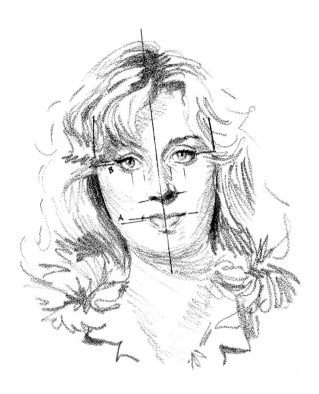

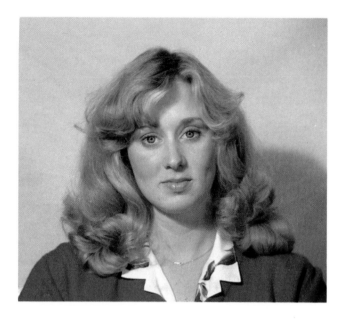

Figure 1: This head is very much an oval shape that's just a bit flattened on the right. The spacing of the eyes is quite symmetrical, but the left one angles up. Note the difference between the lines at B. The nostrils are uneven; the right one is higher. The corner of the mouth on the left rises above the usual right angle to the vertical line, by the amount shown at point A. I must be sure to position all the features of the sitter based on the outward tilt of that vertical line.

Figure 2: The sitter for this first color demonstration is Lorin, a blonde woman with a pretty, bright face. Her hair color, large eyes, full mouth, and high-keyed skin tones lend themselves to a full color painting.

The colors and values of blonde hair are interesting because they have such a broad range, as compared to a brunette. The values in blonde hair range from nearly black to almost pure white in spots, and the colors in the hair encompass the whole spectrum of the palette.

The task, in addition to capturing the special characteristics of Lorin's face through the usual steps, will be to discover the colors that both convey and enhance her likeness.

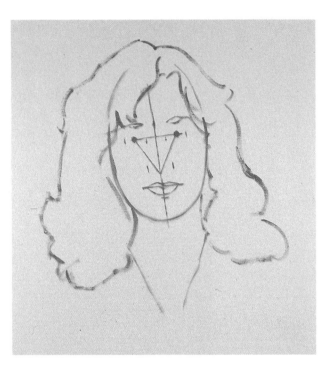 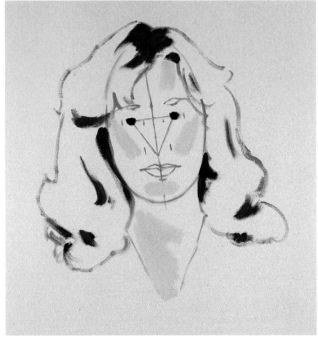

Step 1: I begin as I did for the black-and-white demonstrations by outlining the basic shapes with as neutral a color as possible, using a #4 Filbert hog bristle brush. Yellow ochre is a good choice for this because it will blend nicely into the hair and skin colors.

What can be seen of the head under the hair appears to have an oval shape. It has a slight tilt that will affect its construction. An analysis of the face reveals that the eye line isn't exactly perpendicular to the vertical line; it tilts up on the right side. I paint in the outlines for the individual features, spotting in the eyes and marking their boundaries and those of the eyes and the nose wings. The central triangle configuration is indicated, which helps to position the eyes, nose, and mouth.

Step 2: To establish both color and value, I use burnt umber for the parts of the hair which are deepest in color, like the top of the head, along the sides of the face, and a few other small places. The umber is used for circles to form the irises.

For mixture of color in this painting and in all the following color work, I'll try to give you some idea of the quantity of colors mixed together. However, I can only make an estimate; it's mostly trial and error. It would be handy if you had an extra piece of canvas for testing the combinations before applying them to your work.

Mix a generous pile of the basic flesh tone for this head. Using a one-pound tube of white, squeeze out about three inches of it. With a palette knife, add about one-half inch of both cadmium yellow and thalo red, thoroughly mixing them into the white. This combination can be a base mixture for other colors later. It should look a little darker than the canvas now, but eventually it will be one of the lightest tones on the face.

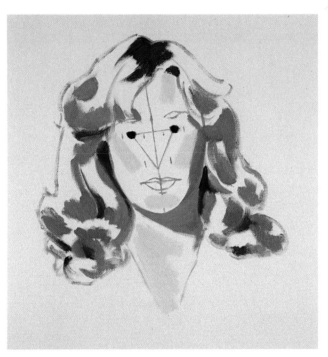

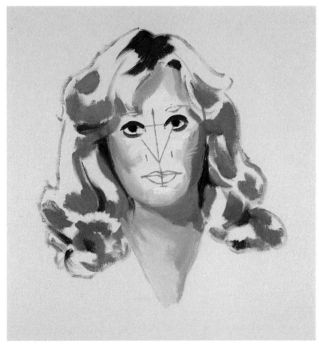

Step 3: An ample quantity of the warm flesh tone in the shadows is needed, and this time start the mixture with the colors cadmium yellow and thalo red, adding a lighter component to those, which can be the flesh color you've mixed in Step 2. It will take about two inches of cadmium yellow and one inch of thalo red from the tubes, plus a very small amount of the light flesh color (a brushful). Test the color to see if its tone value is midway between the dark umber and the basic flesh tone. Use this for the large shadow on the right that goes down into the neck. Then the many parts of the hair are blocked in with this color as well. These are places that are halfway points between the darks and the general light blonde tones. Notice that the strokes used for the hair are done with a dry-brush technique to create a soft texture. Now the middle value has been set for all colors.

Step 4: The halftones on the forehead and the sides of the face are almost the same color mixture as that used for the shadows, but they are lighter. You'll notice that the sitter's flesh begins to get warmer in the light, and rosy around the cheek areas. To achieve this warmth, I add bits of cadmium yellow and thalo red to the shadow mixture, with more red used around the cheeks but less on the forehead.

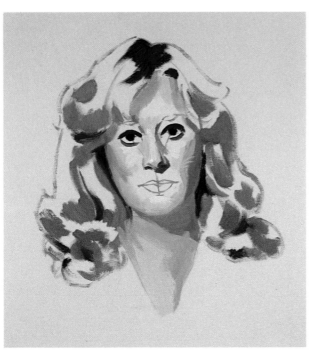 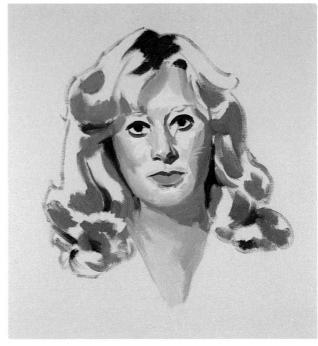

Step 5: *Starting with the nose, I begin to paint the features with the same colors used for the head itself, but on a smaller scale. The values on the nose range from the dark cast shadow, which consists of umber and light red, to the side in the light, which is painted with a halftone that contains a touch more orange. The bridge between the eyes is a cooler halftone with a little light red in it. I paint a simplified frontal plane to the nose, using a light flesh color. It's not too soon to add the highlights on the nose tip with a touch of pure white. The nostrils are indicated with equal amounts of burnt umber and thalo red. Notice their positions: the right one is higher than the left. For these I use the shadow color, which also helps to shape the underside of the nose.*

Step 6: *In previous demonstrations I've worked on the eyes after the nose. But the order of steps needn't be rigid once you become fairly proficient. It's more convenient here to work on the mouth next. I use an equal mixture of thalo red and white and take a little bit of thalo red-violet on the tip of the brush. When painting the upper lip, I omit the white. In this step the tones around the mouth next to the lips are also painted, in order to give shape to the lower area of the head.*

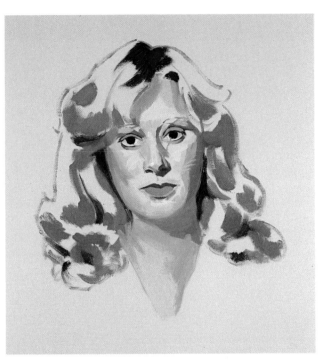 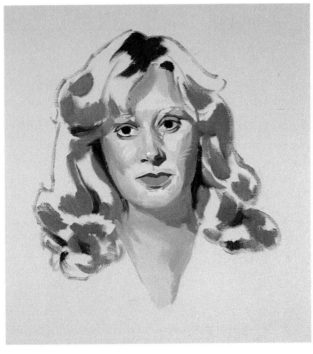

Step 7: Now the eyes are first blocked in by painting the shapes above them. Using some of the original shadow color, I paint around the top lids with a loaded #2 Filbert hog bristle and, by cutting in close, let that color blend into the edge of the umber color. I pick up a fresh brushload of color for each eye. Over the top of those strokes, light dashes of paint show the puffing out of the eye sockets. A tone a step darker than those dashes, consisting of light red and white, is painted over the dark umber lid. There's a blue-violet cast to both the upper and lower lids, which I create with a mixture of light red and white. The effect is slightly different on the lower lids, as the color fades in toward the tear ducts and becomes flesh color. Finally, I spot in the whites of the eyes, which are actually composed of the flesh color mixture and contain four different values.

Step 8: There's more development of the nose here, around the eyes and where the nose planes merge with the face. Another crease is added under the eye on the right, coming from the nose near the tear duct and going into the cheek. A lighter orange is used to bring that plane, on the right, out farther on the cheek. I dip into my original flesh mixture and add an equal amount of the warm shadow color I've already prepared, using it for the shadow value alongside the nose. I add white to that mixture until it's a lighter version, for the other side. These strokes both bring out the bone structure. Both sides of the nose wings are painted and blended into the cheeks. The one on the right is slightly lowered in tone with light red, while on the left one a pale orange is used.

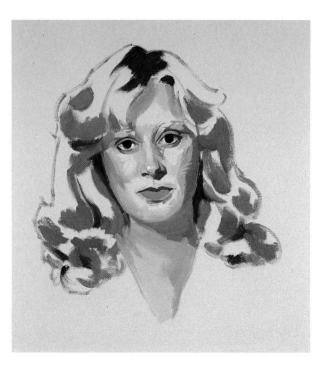

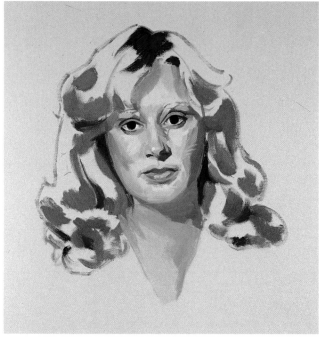

Step 9: I return to the eyes now and refine them by getting the underside of the upper lash line strengthened with light red, umber, and thalo red. This combination will vary from pure thalo red at the tear duct, half-and-half light red and thalo red over the inner white of the eye, then mostly burnt umber on the outer corner. It should be blackest over the pupil. Adding a touch of light red on the outer lashes completes the transition of colors on the lash line.

I give a more precise shape to the inner corners of the upper lids as they form an ever lighter path looping around, down into the cheeks. It's here that the correct distance between eyes and the correct position of the irises are established so that the eyes track correctly. In this painting their placement seems O.K. but the lids at the sides need to be tightened a bit.

I indicate temporarily the moisture in the tear duct corners using white with only enough thalo red to tint the color pink. The

lower lids appear quite a bit deeper in tone than the upper ones, so white and burnt umber are used to suggest their deeper gray-violet hue. (Those two colors usually don't produce a violet, but in this painting, in relation to all the warm colors present, that mixture appears to be gray-violet.)

Step 10: Now the mouth needs to be shaped more with the addition of a lighter pink (composed of the lower lip color that was previously mixed and a touch of white to lighten it) to the lower lip, in a crescent shape. Pure thalo red is added to the upper lip along the center. The mouth is given more definition by painting underneath the lower lip. It's light next to the fleshy part and then it turns under with darker values, becoming quite dark below. Small flicks of middle tones show the turn-in at each side of the mouth.

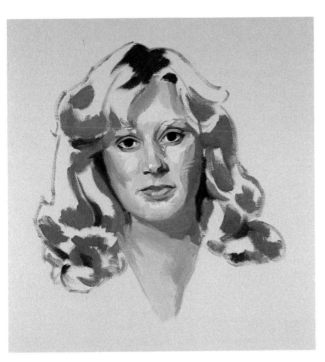 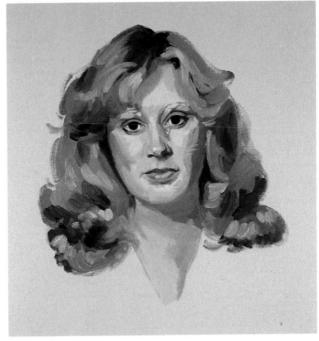

Step 11: *The bare canvas intrudes in areas between the nose and mouth, making it difficult to accurately determine values, so I paint in these areas with flesh colors that have already been mixed. Going from left to right between the nose and mouth, these tones are light, dark, light, and darker again, blending into the cheek color and also softening into the cast shadow of the nose. I use fingers or a blender to soften the edge of that cast shadow and some other edges in the area. On the triangle next to the nostril where the values are very light, I use a flick of the color mixture for highlights.*

Step 12: *New batches of color now must be mixed for the hair, using the same degrees of cadmium yellow, white, and light red. Burnt umber, white, and yellow ochre are combined to form the darker hair color. I work on the hair in sections: one section on the left above eye level, another down from eye level, and then the lower mass of curls at the*

bottom. On the right side the hair is sectioned off in a similar way, and each section has its dark shadows, its warm middle tones, and its highlights.

The upper left hair section starts off dark and then becomes a light halftone down to a rich orange. There's a special highlight over the forehead. The middle section on the left starts with dark umber and goes to a rich red, mixed from cadmium red light plus yellow ochre. This area gradually gets lighter, turning under with more color in the center. The bottom curls contain sharp contrasts, from umber to pale yellow.

For the upper right part of the hair which is close in value, I use yellow and white plus umber with a few dark accents. The center right hair area is a mixture of the first batch of hair color and light red in equal amounts, but one part of the first mixture to two parts burnt umber for the darks. The light, yellowish areas at the bottom right are the same amounts each of cadmium yellow, white, and the base hair color.

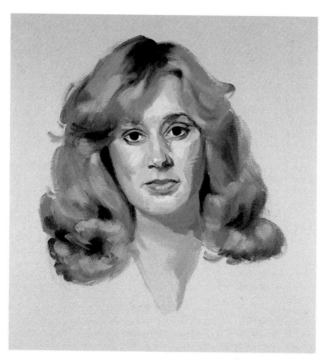

Step 13: I'm now ready to shape the forehead and eyebrows. Using the same flesh colors, the forehead is painted in planes that turn gradually to the lock of hair on the right. The eyebrows are various mixtures of yellow ochre and burnt umber. I keep all their edges soft. The eyebrow on the left becomes part of the hair, which crosses it. While working there, I develop that wisp of hair and the shadow, a very warm orange, that it casts on the forehead.

Step 14: All the values of the hair are blended together. Any size clean brush works well. I can use a fan blender, but must keep wiping it off so I don't dirty the colors. I paint in the rest of the cheeks. The large highlight on the cheek on the left is white with a very minute bit of thalo red; the other tones are various gradations of orange. By using a number of values, I round out and blend the colors, but I try to avoid having them look too slick.

Step 15: Working across the mouth area and sides of cheeks, more attention is given to the indentation to the right of the mouth. The colors there are painted to blend with the tones around the mouth itself. The bare spots of canvas in those areas are now covered. I'm careful to keep the cheek colors very warm, using plenty of cadmium yellow and thalo red.

Step 16: The graduating tones and colors from the sides of the face continue down to the jaw and chin, but they're not as red. In mixing fresh color for these areas, I leave out the thalo red and reintroduce light red. The jawline seems to become more gray as it darkens and turns under. Using yellow ochre instead of cadmium yellow produces a grayer color. To paint an area that slides into shadow, I go at it one brush stroke at a time, remixing a slightly darker tone for each stroke. I overlap the strokes so that they partly fuse. The jawline gets darker and cooler as it turns under. But once there, it has a lighter, hotter strip (caused by reflected light from the neck and chest), which requires an addition of thalo red and cadmium yellow. The edge of the jaw is lost into the dark recess of the hair on the left. On the right, the jaw requires more burnt umber to turn it.

 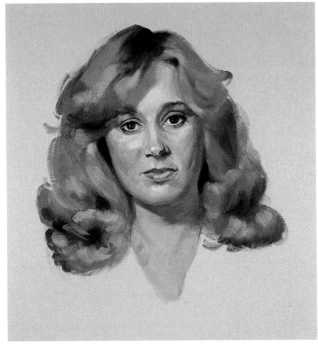

Step 17: The neck should be treated simply and broadly. It has light areas composed of the basic flesh color you used on the face. The light halftones are brushfuls of that color plus a tiny flick of light red to lower it one tone value. I paint in the shadow on the neck to merge with the jaw. That shadow consists mostly of a dark red-brown, made of two parts yellow ochre, one part light red, one part thalo red. Add just enough umber to shade it and only a tiny bit of white to match the value of the shadow. As the shadow goes around to the hair, it picks up a lighter orange. The edge of the shadow on the neck explains the construction of the neck, with modeling held to a minimum.

Step 18: Now I work on completing the eyes, using ivory black for the pupils. They merge with the lash line directly above them. With the black I also show some individual lashes and strengthen the upper line. The lower lashes aren't as dark, so I use burnt umber.

Starting in the center, I mix it with the color already there and gradually make it darker toward the outside. The gray shadows in the whites of the eyes are a combination of white, red, and black. The lashes on that side cast a shadow below the lower lid that consists of a dark flesh tone. The upper lids follow the contour of the eyeball, which is demonstrated by the changing values along its curve. These changes become subtly lighter over the center of the eye above the iris.

The inner eye path becomes more red and lighter as it curves around the tear duct. I use a fine-pointed sable to make the clean pink line for the top of the lower lid. The irises are a combination of ivory black and cadmium yellow, which produces a nice green. I also add a speck of pure red to give the eyes life. The highlight on the eyeballs is pure white, as are the moist spots in the tear duct corners. Another spot of white on the lower lid gives the eyes their "dewy" look.

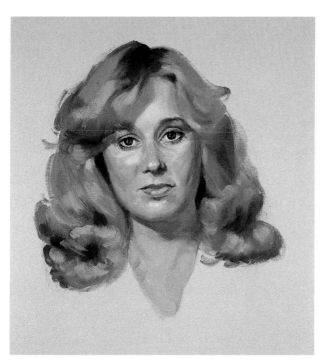

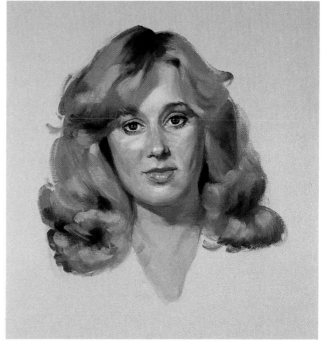

Step 19: The final step in painting the nose consists mostly of softening all the hard edges. I also darken the front nose plane with a subtle yellow-orange mixed from the original orange shadow color, white, and cadmium yellow in equal amounts. Around the nose tip on the shadow side, there's a deep red-orange strip that turns into the shadow, which gives the nose its characteristic redness without making the whole tip red. An intermediate value is painted around the bottom nose plane before the shadow is added, which takes the sharpness out of that edge. I reinstate the nostrils and make sure that the one on the right is higher than the other.

Step 20: I finish work on the mouth by softening its periphery. It's important that the mouth doesn't appear to be "pasted on." I round out the deep lower lip and give it a moist look by accenting it slightly with white highlights. The lower edge of that lower lip has two darker places on each side, which are indicated by use of more thalo red in the white. The shadow under the lips is softened as it moves into the chin.

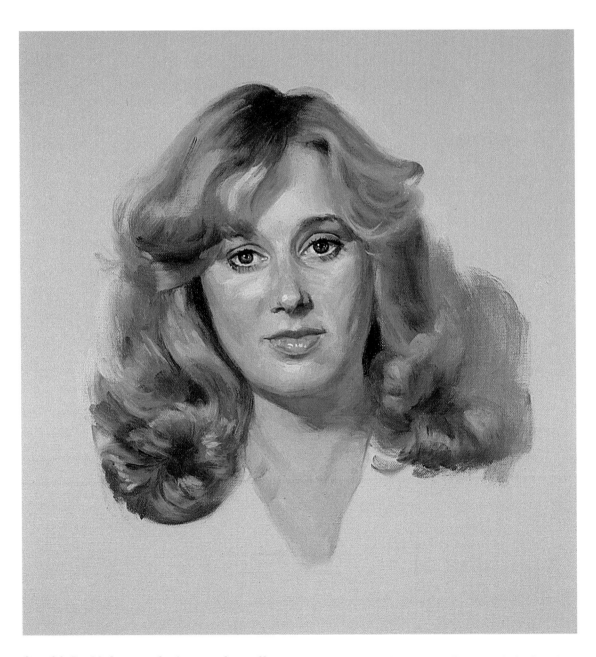

Step 21: I add the cast shadow on the wall at the right, using equal degrees of white, black, and cadmium yellow. The edges are kept soft and indefinite to blend well into the hair. An important step here is to soften the hair into the background all around the head. Mixing a color that approximates the canvas tone, I work the whole hair periphery into it so the hair becomes ultra-soft-looking with many different edges.

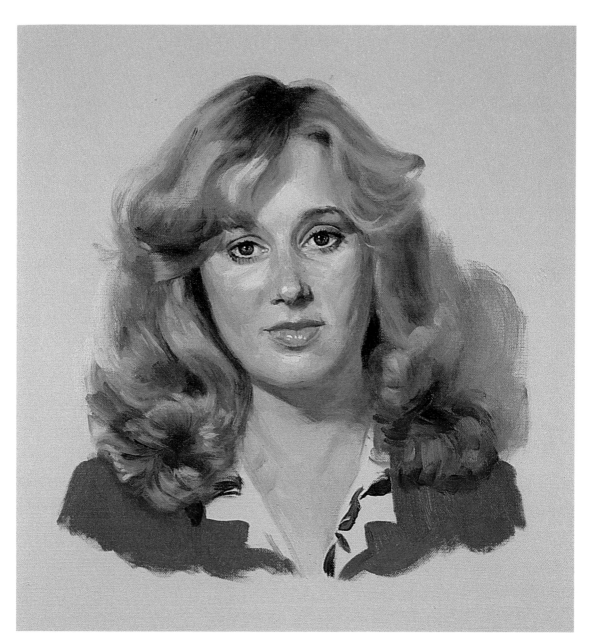

Step 22: Now, for the sitter's garment I use thalo red, to which I add cadmium red light for the light accents and thalo red-violet for the dark areas, such as the shadows cast by the hair on the sweater. Where the hair meets this color, I soften the edges by blending. On the right, the garment color shows through the hair very noticeably, giving a transparent look. The only maverick color used in this painting is the little bit of thalo green for the figures that are loosely indicated on the blouse.

Step 23: Using a dry brush and my fingers, I blend many of the facial tones around the cheek area. Then I find that the dimple on the right is too pronounced, so I lower its *value by a step. This sitter's complexion is rosy overall and forms a nice contrast with her blonde hair, which contains many subtle color changes.*

Step 24: In this final step, I add the gold chain and accentuate the shadow of the blouse. On the right, more hair is added to the big swirl of hair. On the forehead, the cast shadow of the hair is too flat and there isn't enough light coming through it. I correct that by lightening up the shadow with selected lighter streaks. A couple of strands of hair are added on the right side of the right cheek.

Color Demonstration 2

Redhaired woman

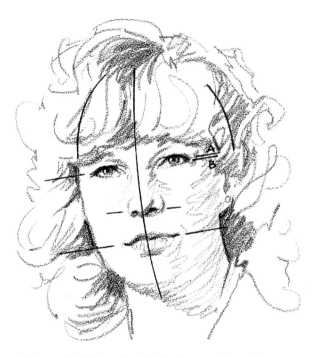

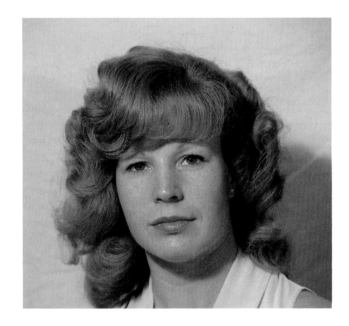

Figure 1: *Although a little longer than the head in the previous demonstration, Carol's head is also an oval. The curved line on the upper right is the back of the skull, not the boundary of the face. The line of the oval on the right is lost in this slightly angled view. Also, the vertical centerline becomes curved as a result of the angle of the head. One of the most subtle variations on her face is her eye line. Although it's hard to notice on this small drawing, in the painting, which is nearer to life size, it makes a great difference in her appearance. The right eye is lower than the left by the amount shown at line A-B. The nose line tilts up on the left side, while the mouth line is parallel with the eye line.*

Figure 2: *Each of the color demonstrations provides different painting experiences. In this one, Carol's flaming red hair allows me to use a full palette of rich colors. If you could examine her hair closely, you would find many colors in it in addition to the red—even a touch of green. Her skin color is different from a blonde's such as Lorin's in Color Demonstration 1.*

Carol's likeness resides in the bright, cheerful quality of her eyes and mouth. It also comes from an inner radiant spirit via the structure of those features. I hope, by arranging many tiny brush strokes in just the right places, to convey that spirit.

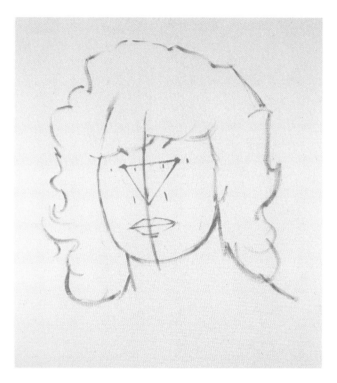 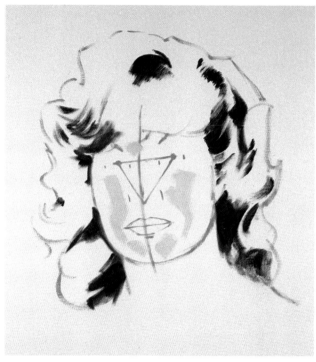

Step 1: When thinned, burnt sienna appears fiery red, so it seems like a good choice for outlining a redhead. In this step I combine the work accomplished in the first two steps of the preceding demonstration. However, my procedure is the same, and I begin by outlining the shape of the head. Carol's head is slightly longer than a regular oval, and she has a deeper jaw than the previous portrait subject

After determining where her bangs cross her face—about halfway from the top of the hair to the chin—the eyebrows can be positioned. This also allows for a check on the eye level. Notice that the eye line and the mouth lines aren't parallel. (Check the drawing on p. 112 that analyzes this head, if you have trouble spotting that proportion.) The eye on the right is a bit lower than the one on the left.

Step 2: As in previous demonstrations, this is the stage at which I establish the two extreme values to be used. In red hair, there is not only a variety of tones but also a wide range of colors. For the darkest parts of the hair, I use burnt umber. I can see a deep red in that color and I add a little cadmium red light to it. These dark areas occur mostly around the face. The proportions of the colors I give you are what I have used, but remember that different brands of oils have varying tinting strengths, so you may have to adjust them to the correct colors or values as necessary.

For this portrait, I use as a base color (compare to the first color demonstration), three inches of white (large tube), one-half inch of cadmium yellow, and only about a quarter of an inch of cadmium red light (all regular size tubes). Usually cadmium red is very potent so you can't use as much of it as thalo red.

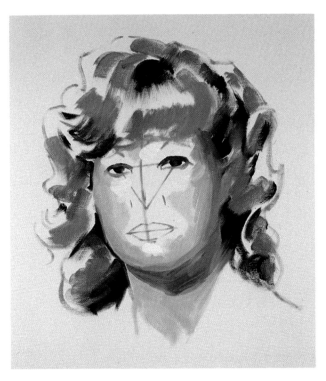
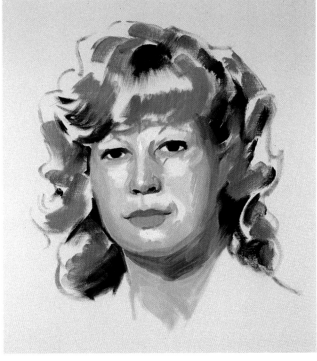

Step 3: There seems to be quite a jump in development in this step, but actually just four main items are painted. First, for the shadows on the right going down into the neck, I mix the same portions of light red and cadmium yellow, plus half as much cadmium red light to produce a deep, rich orange. Next, that color is also used for the shadows in the hair. Third, an additional darker halftone occurs where I brush into the umber, such as on the right around the ear. And finally, the irises are defined with pure umber, as well as the eyelids, for which I add some red to lighten them a bit.

Halftones that shape the face around the sides and bottom are brushed into both the shadow and the lighter color. Using the basic flesh combination, dipping just a little white for the lighter areas, and barely nicking the light red for the slightly darker halftones, I block in the neck.

Step 4: This sitter's likeness begins to emerge as I block in the eyes, nose, and mouth. The routine of starting with the nose first is continued here. Using some of the same halftone color that's on the right side merging into the shadow, I paint the sides of the nose. This immediately gives the nose a three-dimensional quality. The nose's side planes are fairly straight along their length in the center. The center plane is a warm, light halftone mixed from the cadmiums.

The underside of the nose is painted with equal amounts of burnt sienna, cadmium red light, and white, while the nostrils are pure burnt umber. (A mixture of one part cadmium red light, one part light red, two parts cadmium yellow, and three parts white can be used to delineate the nose wings and that halftone shadow on its tip.) Now it's time to paint some of the tones between the nose and eyes,

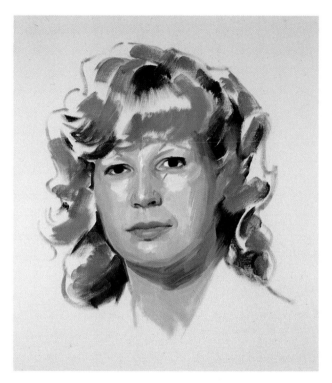

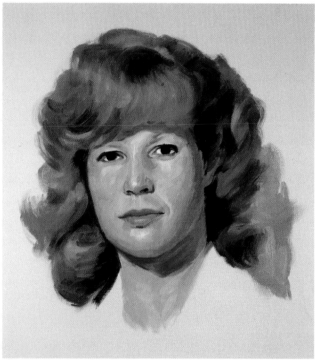

Step 5: I keep the features moving along, first by painting subtle tones on the length of the nose to lessen its chiseled look. These tones are very high-keyed oranges mixed from cadmium red and yellow with white. The line that previously delineated the nose wings is blended into the lighter parts to round them more. The eyes are strengthened by drawing in the upper lid lines that come down into the corners next to the nose. For this, I use mostly burnt sienna, merging it with the umber over the center of the irises. I've drawn in the reddish inner corners of the eyes. The tones become darker as they rise around the upper lash lines. The lower lash lines are somewhat brown. With dashes of the half-tone shadow color, I paint in a crease between the eyes and eyebrows.

Tones are developed between the mouth and nose with the same colors that I mixed for the planes of the face. The separation line between the lips is strengthened.

Step 6: Before adding too much detail to the face, I start to work on the hair. It's a change of pace, because the hair is painted broadly. Its colors range from bright red, to yellow-red, to a brown. Here and there an addition of the deep red-tinted umber mixture is used. Cadmium red light, cadmium yellow medium, light red and burnt sienna in equal amounts are abundant in these hair colors, with a modest amount of white mixed for the highlight area around the bangs and a spot on the right. I blend all of the large areas somewhat but don't go too far, because I want the look to be spontaneous, if possible. While blocking in the hair I add the background shadow, using yellow, white, and a little umber.

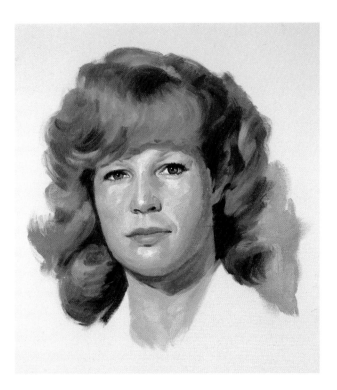

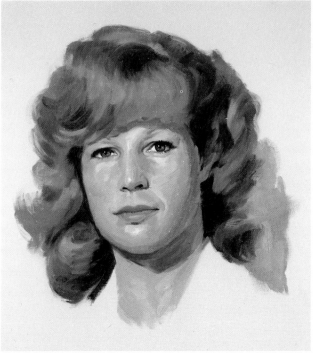

Step 7: *If all the previous steps have been followed carefully, the larger elements of the face will already be established. Now it's a question of refining them and adding details. This is accomplished by modeling many of the features, such as the area around the eye instead of a sudden jump in value from the dark upper lash line into the light-colored flesh above it. I blend that dark tone to make the transition more delicate. The dark, curving strokes on the nose bridge next to each eye need to be blended into the lighter colors on the front of the nose, especially on the right. This refinement doesn't change the drawing but gives more depth to that area.*

Now comes the fun. To paint in the eyes, I use a grayed green which is a mixture of ivory black and cadmium yellow, plus white. The eyes, specifically the irises, are hardly ever composed of just one color. These eyes even have a speck of red in them. My

last touch here is to flick in the highlight on the eyes with a point of pure white.

Step 8: *Moving down to the nose, I subdue the linear effect on its left wing by using a mixture of white, light red, and cadmium yellow medium, in approximately equal amounts. The point of the wing below is given a more definite shape. On the nose's side plane on the right, I extend the orange shade that dwindles into the cheek; it wasn't wide enough and didn't blend smoothly into the lighter tones. A little farther down, I refine the values on top of the nose wing.*

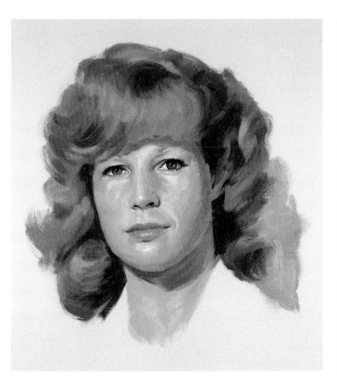 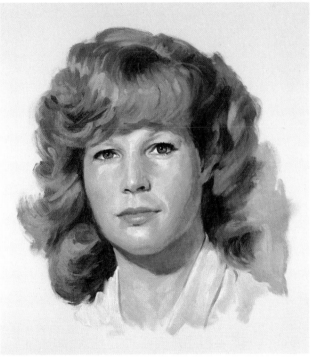

Step 9: On the mouth, I improve the shape and texture of the lips. Along the upper lip, two small points are emphasized with highlights. I temper the rest of the mouth's top edge with a color that's one value lower than the flesh directly above. At some places, for example on the right, this tone blends in with the red, fleshy part of the lip.

Step 10: In this step, I develop the top of the dress, using mostly white and adding a touch of red-violet to tint it in the light areas. Where it turns into the shadow, I add more red-violet. Again I mix and test until a desired value is reached. I also complete the edge of hair that merges with the dress. The edges next to the neck are accented with shadows. The sheen on the waves of hair is highlighted with strokes of an ochre-like color composed of two parts yellow ochre and white to one part light red. On places like the left side, the curves of the locks are developed with additions of both a darker sienna color and some pale red tones. The curls emerge from the shadows and retreat again, like those next to the cheek on the left side.

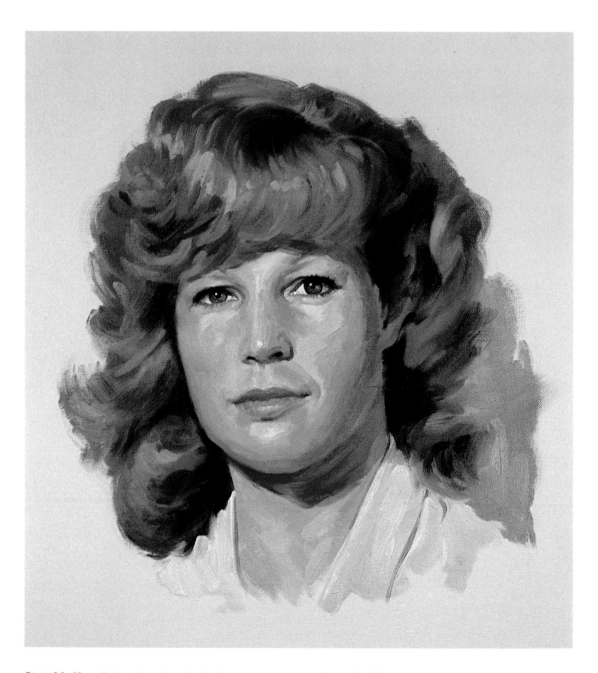

Step 11: Here I develop the whole face, pulling values and colors together. The areas that need additional work are the shadows that come into the light and the cast shadow on the neck. The major time here is spent refining the tones on the cheeks and around the jawline. A light touch should be used so that the basic structure isn't disturbed.

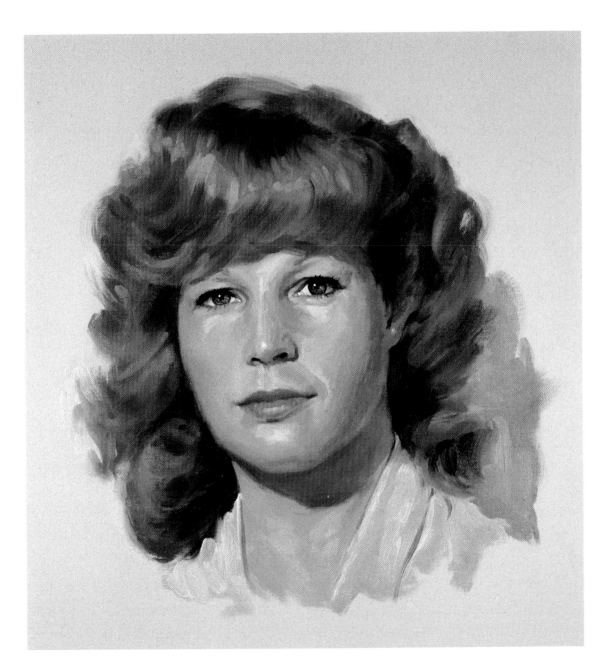

Step 12: Finally, I blend all value changes in the hair and soften its outer edges. The bottom of the bangs is painted to give an appearance of fading in and out along its width. A few of the shining lights above it are left bright, while others are mingled with the hair color. Painting in the earring provides the final touch.

Color Demonstration 3

Asian man

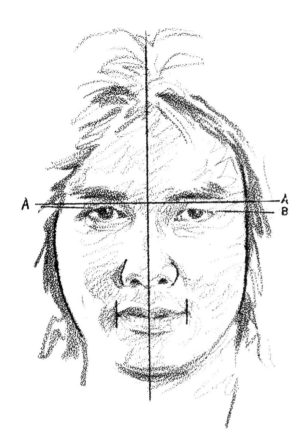

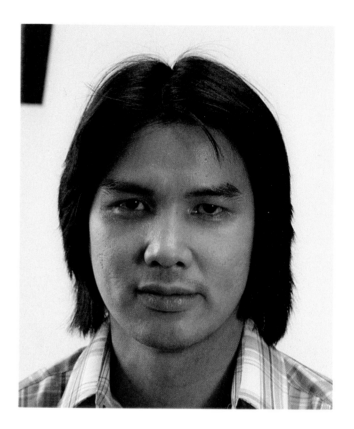

Figure 1: *Lito's head is an oval that appears flattened on the right. The eye line at A is considerably different from a level line shown by line B. The eyebrows don't have as much of an angle and tend to follow line A. The outside shapes of the nose wings are different from each other; one is more curved. Although the center of the mouth falls on the vertical centerline, its outer boundaries swing the whole mouth to the right.*

Figure 2: *My sitter, Lito, is a handsome man with a slight brooding look to his brown eyes. His Filipino-Malaysian heritage has given him beautiful bronze skin tones and prominent cheekbones. He has a sensitive mouth line and his gaze is strong. Capturing his likeness will depend largely on establishing the skull structure and the size and placement of the features in relation to each other. There isn't much irregularity in his features, so I'll have to analyze his face carefully to determine what characteristics set it apart and make it unique—make it his likeness.*

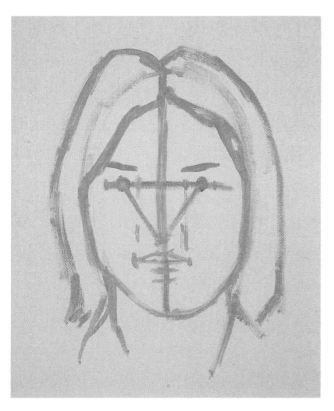

Step 1: I begin to draw in the head, using a light gray color which consists of ultramarine blue, burnt umber, and titanium white. A light color works well when painting a portrait on a white background. Later on, any cleanup around the outer edges will be easy because the light gray can be completely covered or wiped out. This gray also mixes with the edge of the black hair and softens it.

I sketch in the skull a little smaller than actual size—about 8 inches from the top of the head to the chin. The vertical line of the face is perpendicular instead of at the slight angle you see in the analysis of the head. Here and in some following steps, I proceed as if this were just an average head. Later, I'll make the slight changes that are needed to create a likeness.

Step 2: Next, I begin to paint in large masses of color, using a generous amount of a mix-

ture of all the colors that make up the skin tone, which is one part each of yellow ochre and burnt umber, and one-half part each of cadmium red light and cadmium yellow medium.

The same base, mixed with some more umber plus cadmium red light is used to paint in the streak coming down the forehead. This color gets slightly lighter as it mixes with the gray used to sketch in the head and features; that's O.K.

Now, about the same amounts of burnt umber and thalo red-violet plus only a touch of ultramarine blue are mixed together to produce a warm black which is used on the eyebrows, the irises, the boundaries of the eye sockets, the indentations at the sides of the nose and mouth, the nostrils, the separation line of the mouth and underneath it, and the chin line. To this dark mixture I add more ultramarine blue and indicate the hair just around the face.

Step 3: I add more of the hair color to achieve an approximation of its shape and soften some of its edges. After adding more brown to the hair color, it's used for the eyebrows and the shadow of the collar. To accurately portray the lights on the left side of the face, which are cooler, I add white to the middle flesh tone. I use another cooler color for the left side of the face at the forehead directly above the eyebrow, two spots on the left eye, the dimple on the left cheek, a stroke above the mouth, along the chin, and on the neck. This cool color is a mixture of three parts white, one of thalo red-violet and one of viridian green.

Finally, with a darker value of the new, cooler color, the dark plane at the bridge of the nose and the accent on the left center of the chin are started.

Step 4: For the upper lip, I use a brushful of thalo red-violet and only mix in a tiny

amount of viridian green. I wipe the excess paint off the brush and barely touch the pile of cadmium red, laying it over what I've already painted. For the lower lip, I take that upper lip color and add enough white to raise it one step in value, and also just a touch of viridian green to cool it. To change the planes across the mouth, more white is added on the left, and white with cadmium red is used on the right. The small highlights on the mouth are made with the same colors. The separation line of the mouth is restated with a burnt umber and pure violet.

Here I begin to indicate the little deviations in features that constitute Lito's likeness. For instance, that separation line on his mouth droops down from left to right. I cut into the upper edge of the lip with light flesh colors. The bottom of the bow here shifts a bit to the right. Although he's shaven, the dark hairs show in varying degrees across his upper lip.

 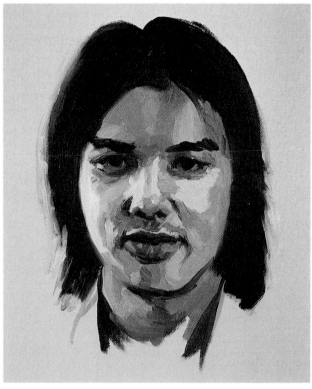

Step 5: Here, the sitter's left eye is slightly higher than the right, so I repaint the iris to position it correctly. Also, the left eyebrow now has to be raised.

If you check with the photo, you'll see how the lines of the eyes and eyebrows angle up a bit. Now that I have that angle established, I can put in the black line around the eye sockets. You can see strong evidence here that the so-called "whites" of eyes aren't really white at all. In fact, they almost always contain four or so different values that are rather darker than you may realize. Notice that the white at the extreme left is so dark that it's hard to see the difference between it and the iris. Besides being one tone lighter than the iris, it's a warmer color.

The puffy part underneath the left-side eye catches the strong light coming from the left. For it and the "lighter whites" of the eyes, white is added to the cool shadow mixture.

Step 6: The dark halftone that starts under the large light on the right side is painted to make a wide, sweeping curve that turns that part of the cheek slightly under. Now I work on the nose. The creases around its wings are more tightly drawn to conform to Lito's likeness. The left one is cut in close and higher. On the right, the angle of the crease is changed. I restate the nostrils with burnt umber and red-violet to keep them warm. Modeling the end of the nose is done with a squarish stroke of warm pigment that is carried down the end and along the underside of the right wing. Using three values across the wing, I rework it and leave a pinpoint of bright highlight on its end. The line along the base of the nose is delineated. And I lighten that strip on the middle of the nose as well as the angling plane on its right side.

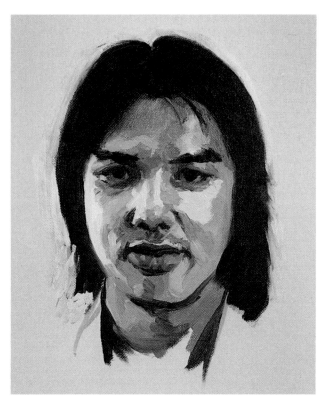 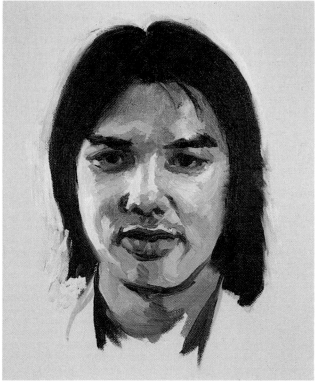

Step 7: The hair requires reworking because its shape is too high and puffy; so the existing black there is wiped off with a towel. I refine the forehead, using the same colors as before. The little light shape in the corner of the forehead is refined, as well as the light on the right.

The edges around the hairline are a concern. A mixture of red-violet and viridian is used as a transitional color from the hair into the flesh. I blend that color into the hair and then blend the cool flesh tones into it, especially on the left side of the forehead. The cast shadow and the little bit of light above it make the wisp appear to curve outward.

Step 8: Colors and values across the center of the face and on the cheeks are refined. Using a mixture of warm colors—cadmium red light, cadmium yellow light, and white—I make halftones on the left side of the forehead.

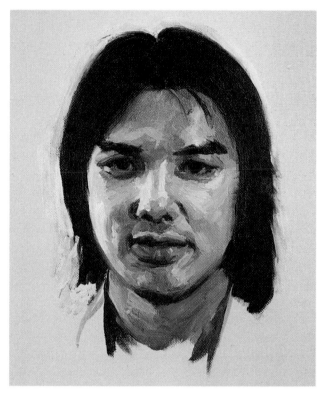

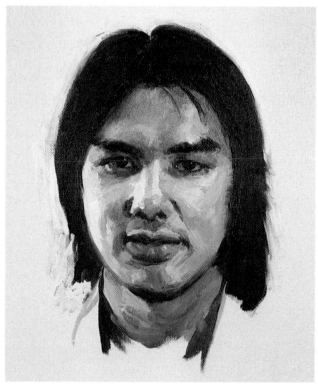

Step 9: The edge of the upper lip needs softening. This is done by using the same colors mentioned in Step 4, but they're blended together more. A softer effect on the upper lip is achieved by adding cadmium red light to its upper half. I darken the value on the center of the chin while softening its outline. The neck construction is developed with the addition of tones and blending. On the right side of the face at cheek level next to the hair, some edges are softened. I do this by flicking a clean, dry brush across two adjacent edges, being careful to use a different brush for each color.

Step 10: Now, I concentrate on refining the eyes. When I altered the nose wing on the left, changing its position, it threw off the position of the eye on that side. Now it's over too far to the left. So, I repaint its iris first, picking up a brushful of dark ultramarine blue and burnt umber on a #4 Filbert brush. I realign the iris and determine its new position by measuring upwards from the nose and in from the right eye. Then, I rebuild the eye structure around the newly positioned iris. Highlights are added to both eyes with a small #2 brush and titanium white, with just a touch of cadmium yellow.

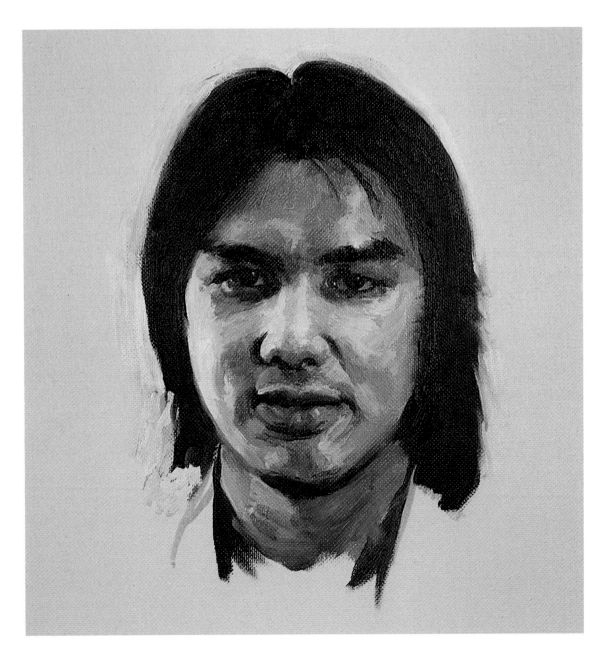

Step 11: The nose is softened and the orange strips down its front and side are made lighter. The highlights on each side are re-shaped to achieve better construction. The accent on the left-side nose wing is enlarged and the planes around the end of the nose are blended. The strong light streak on the right side of the nose is painted closer to the bridge.

As I soften and blend the entire portrait, I'm careful not to allow it to look too "slick." Working from a photograph can have that type of influence on your painting. This portrait will have a better quality if it's a little "brushy" in appearance. If you use plenty of paint and keep it juicy, you can have a choice; you can stop at a certain point and achieve a loose quality, or you can keep softening and blending to achieve a tight rendering.

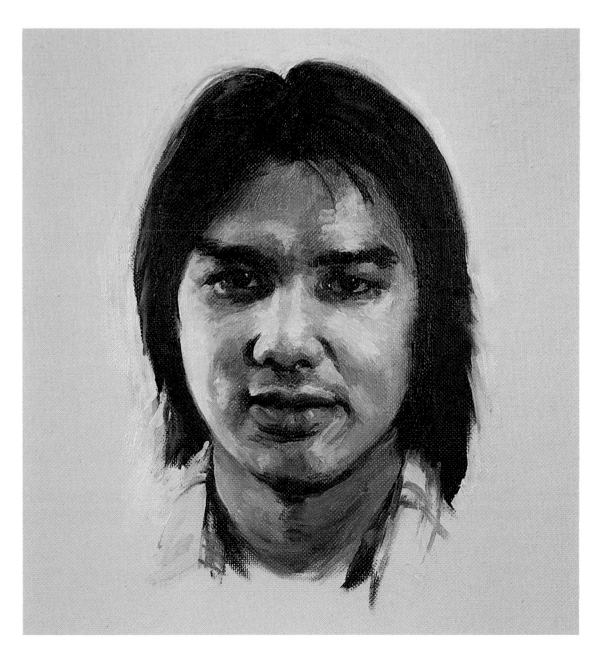

Step 12: Finally, I paint in just enough of the collar to complete the lower part of the portrait. Also, the hair needs a little more refining, and I continue to work on all the edges to create as much variety in them as possible. For example, I brush on little wisps of hair like the ones at the top left side. For highlights on the hair, a mixture of white with just a touch of viridian is used.

Some of the values around the chin are additionally defined and more of the shadows are blended. I notice that the eyebrow levels aren't quite right. The one on the left needs more elevation and the one on the right has to be lowered. As a whim, a little punch is added to the highlights on the forehead and right cheek by using pure cadmium yellow mixed with some white.

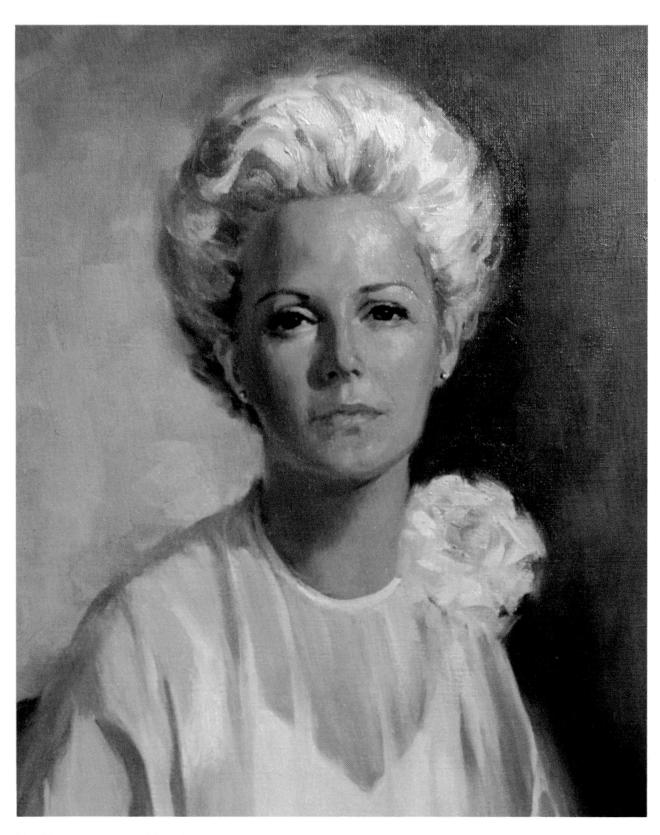

Mrs. Thomas Haggerty *44 x 56 inches Oil on canvas. Collection of Mr. and Mrs. Tom Haggerty.* A combination of live sittings and photos was used for this portrait. The dress had to be painted from life—as well as the face and hands—because the color of the subject's flesh changed when seen through the filmy dress material. But the background and the chair were painted from a combination of photos and the real thing.

Section 4

Selected Poses

Introduction

In the previous black-and-white and color demonstrations, I've purposely chosen to show mostly straight-on views, because it's easier to distinguish the variations in features that help to establish a likeness; but at the same time they're more difficult to paint. In a straight-on frontal view, a delicate balance, i.e., the symmetry, must be maintained between the features, especially the two eyes. If you can learn to capture a likeness in a frontal pose, then you're prepared to try some others, like the profile and three-quarter poses that I'll briefly discuss.

I'll also discuss some techniques for capturing the likenesses of children, although the subject of children's portraiture requires an entire book to be adequately covered. However, you can adapt the same painting procedure that I've demonstrated for painting the likenesses of adults to children, as long as you keep in mind some important facts and admonitions which I'll discuss later in this section.

The Three-Quarter View

When you're painting the straight-on, frontal view of a head, you often determine the proper placement of features by sighting across the face to align them. Poses in which the head is turned away from straight-on—at an angle—are subject to the distortions caused by a change in perspective. So, you must use measurements based on a vertical lineup to determine the proper placement of the features. The perspective caused by this angle also makes the vertical centerline of the face appear to protrude and the mouth and nose that are positioned on this line must appear to do the same.

This head is an extreme example of a three-quarter pose. The drawing on page 131 that analyzes this head shows the lineup of the features. Notice that the eye line is a little different from the mouth line; it slants down to the left. However, the eyebrow line doesn't slant; it's parallel to the mouth line. There's the same distance between the eyebrows and the top lid line, but note that one lid is much deeper than the other. This is one of the sitter's distinguishing features. The nose is small compared to the mouth, which is ideally proportioned.

This portrait subject is shown elsewhere in the book in a front view. Can you find her?

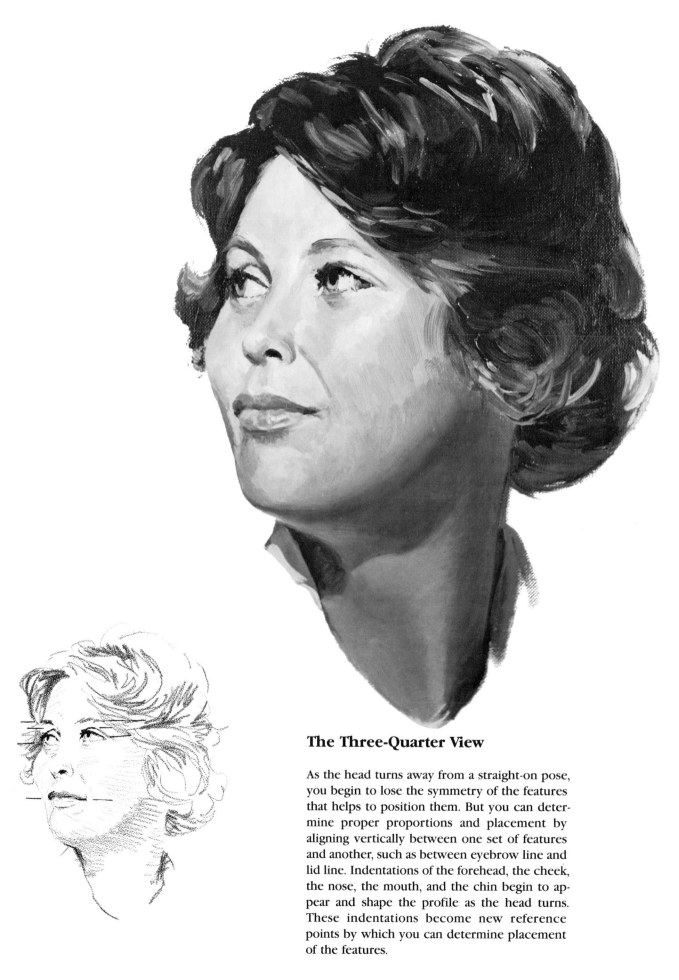

The Three-Quarter View

As the head turns away from a straight-on pose, you begin to lose the symmetry of the features that helps to position them. But you can determine proper proportions and placement by aligning vertically between one set of features and another, such as between eyebrow line and lid line. Indentations of the forehead, the cheek, the nose, the mouth, and the chin begin to appear and shape the profile as the head turns. These indentations become new reference points by which you can determine placement of the features.

Profile View

Portrait painters are seldom interested in an absolute profile view, unless there's something more outstanding about the sitter's profile than anything seen in a frontal view. The profile view provides few opportunities for establishing either a likeness or feeling for the personality of the sitter. There's a certain sense of aloofness or disdain in a profile view that's hard to overcome. A notable exception to this observation is John Singer Sargent's, *Madame Pierre Gautreau.* It was a daring portrait when he painted it, because of that pose, but I have a feeling that he couldn't find anything that pleased him in another view. In any case, the painting is very striking.

Technically, a profile is more difficult to paint than you might imagine. It's almost impossible to get the complete feeling of a third dimension; the results are often no better than a bas relief. In the example that I've painted here, although I've tried to get depth to the head to round it out, it still looks flat. If I make the ear come forward, it creates an unattractive image, because it stands out more than the other features. But if I paint the hair over the ear, I create a vast expanse of it, making the portrait suitable only for a shampoo ad.

If you're compelled to paint a profile view and want to create a likeness as well, this painting can act as a minidemonstration. Treat the features on this face as a series of angles. Next, align them vertically to determine their proper placement. You can use the drawing on p. 133 to assist you in analyzing the correct proportions of the features and their placement in this type of pose.

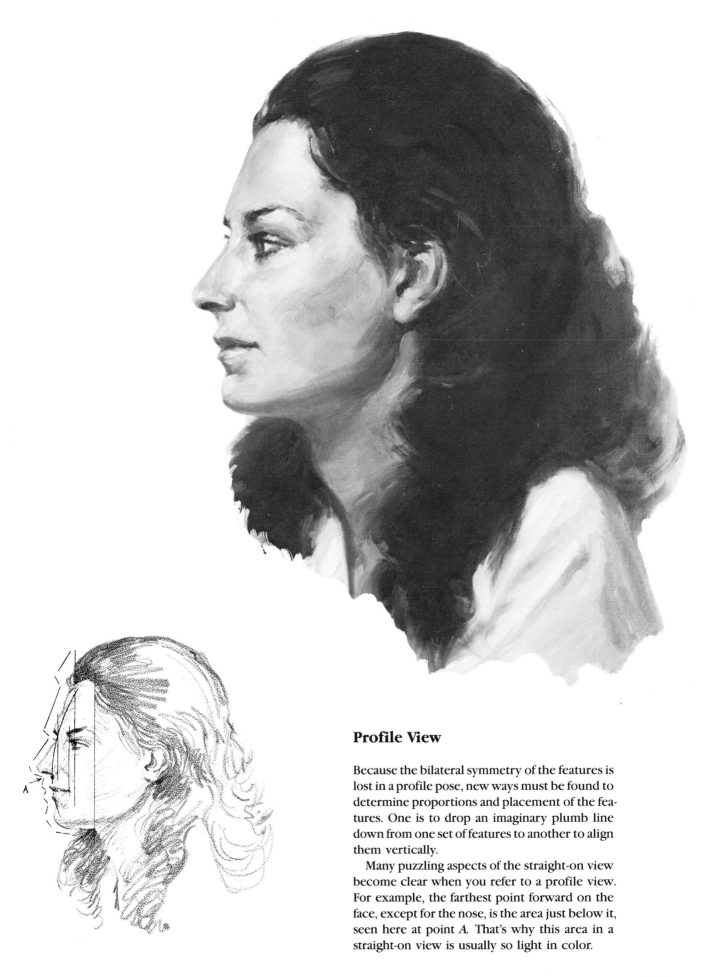

Profile View

Because the bilateral symmetry of the features is lost in a profile pose, new ways must be found to determine proportions and placement of the features. One is to drop an imaginary plumb line down from one set of features to another to align them vertically.

Many puzzling aspects of the straight-on view become clear when you refer to a profile view. For example, the farthest point forward on the face, except for the nose, is the area just below it, seen here at point A. That's why this area in a straight-on view is usually so light in color.

133

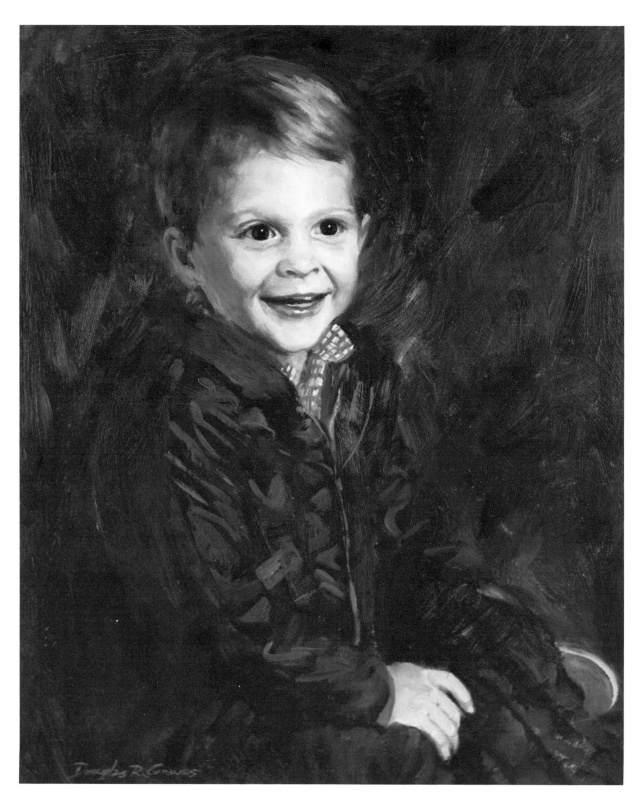

Warren Edward Hines *18 x 14 inches Oil on panel. Collection of Mr. and Mrs. Lee D. Hines, Jr.* This painting is a combination of techniques. There's a tight rendering of the face, while the hands, garment, and background are painted loosely.

Children's Portraits

To paint effective children's portraits, you must have three important qualifications: (1) a painting method like the one I've demonstrated for adult portraits; (2) an ability to observe and capture the effervescence of the child's spirit; and (3) an ability to be a kindred spirit with the child sitter—to enter his special world. A well-known painter, Ariane Beigneux, has been very successful in painting children's portraits because she possesses those three essential qualifications. I've been impressed by her methodical painting approach; yet the results she achieves possess a spontaneity—a special childlike innocence and playfulness.

There's a babyish quality to children's faces (before puberty) that many painters miss, and I think it's because they don't work from life. My most successful portraits of children have been painted from life, even though painting them was the closet thing I've come to playing Pac-man! When your sitter is a child, you need the patience of Job as well as the super hand-eye coordination of a professional athlete, and his stamina as well!

Granting the difficulty involved in painting children from life, using photographs offers a poor alternative. Photographs can be inhibiting, because you can only know about the child from what the photograph shows you. The smallest distortion caused by the photograph can completely alter the child's appearance and lose his likeness.

If painting children's portraits is your goal, and if you relate well to children and can handle the obvious problems that painting them from life involves, you will probably find your work in demand. The art of painting a child's portrait requires the same painting procedure used to capture the likeness of an adult, starting with the fundamentals of keen observation and careful draftsmanship.

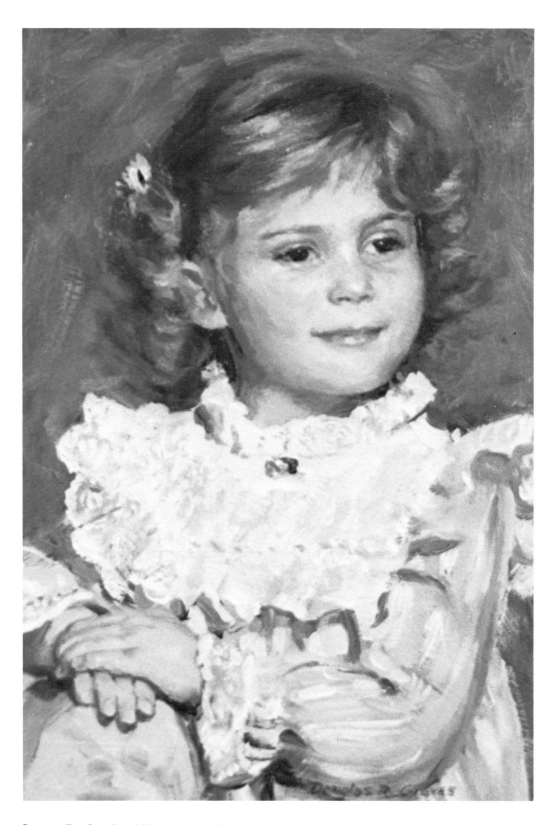

Lauren *7 x 5 inches Oil on panel. Collection of Mr. and Mrs. C. Chester Carlson.*
This portrait was painted from photos. In a painting this tiny there's no allowance for the slightest slip of the brush, not even one hair of it!

Closing Chat

If you've studied this book, you can see how much is involved in just one aspect of portraiture—getting a likeness. To completely cover the entire subject of painting a portrait requires more space then just one book.

But before you go on to the other aspects of portraiture—posing the model, drapery, different types of lighting, etc.—it's a good idea to concentrate on achieving a likeness. When you've mastered that, there are many good books on the other aspects, and I've listed some in the bibliography that follows.

Again, this book is meant as a working manual for just the likeness problem of portraiture. A student of mine once brought a copy of one of my books to class in the most deplorable condition. The jacket was torn, the pages underlined and fingerprinted with paint. I was appalled at first, but then I realized that this student was really using that book!

If I ever have the chance to visit your studio and see this book sitting on your worktable in that dilapidated condition, I'll know I've done a good teaching job and I'll be flattered.

It is for the artist to do something beyond this: in portrait painting to put on canvas something more than the face the model wears for that one day: to paint the man, in short, as well as his features. —James McNeill Whistler

Bibliography

Balcomb, Mary N. *Nicolai Fechin.* Flagstaff, Arizona: Northland Press, 1975.

Blake, Wendon. *Creative Color.* New York: Watson-Guptill Publications, 1972.

Farris, Edmond J. *Art Students Anatomy.* New York: Dover Publications, 1961.

Graves, Douglas R. *Drawing a Likeness.* New York: Watson-Guptill Publications, 1978.

Graves, Douglas R. *Drawing Portraits.* New York: Watson-Guptill Publications, 1974.

Graves, Douglas R. *Life Drawing in Charcoal.* New York: Watson-Guptill Publications, 1970.

Hawthorne, Charles W. *Hawthorne on Painting.* New York: Dover Publications, 1972.

Loomis, Andrew. *Figure Drawing for All It's Worth.* New York: The Viking Press, 1964.

Ormond, Richard. *Sargent: Paintings, Drawings, and Watercolors.* New York: Harper & Row, 1970.

Perard, Victor. *Drawing Faces and Expressions.* New York: Grossett & Dunlap; London: Pitman Publishing, 1958.

Sanden, John Howard. *Successful Portrait Painting.* New York: Watson-Guptill Publications, 1981.

Speed, Harold. *The Practice and Science of Drawing.* New York: Dover Publications, 1970.

Index